MODERN CALLIGRAPHY WORKSHOP

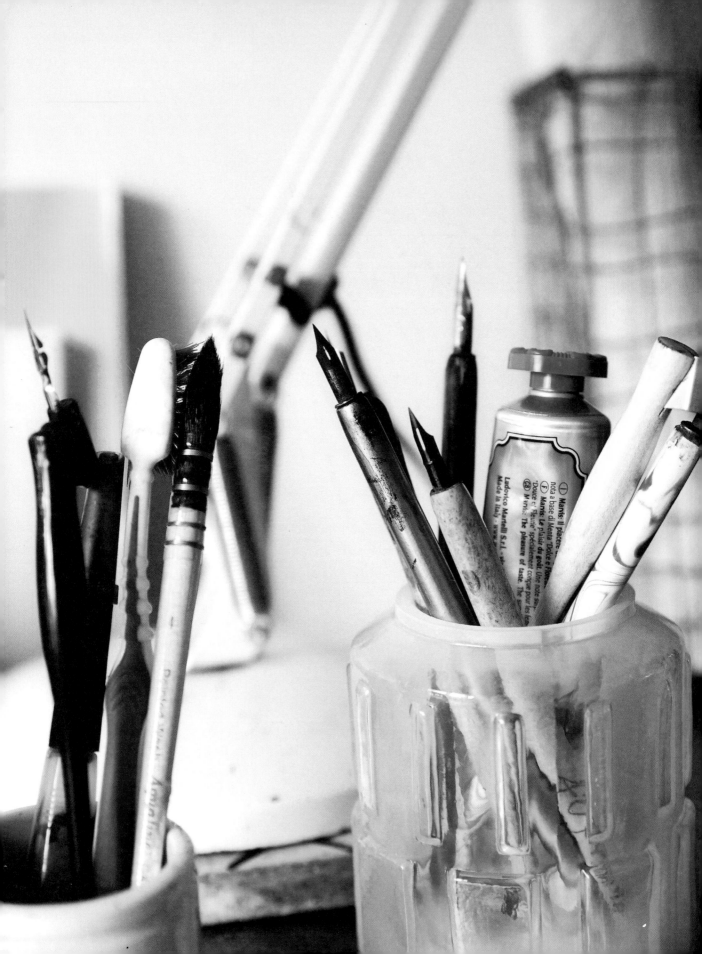

Modern Calligraphy WORKSHOP

THE CREATIVE ART OF PEN,
BRUSH AND CHALK LETTERING

IMOGEN OWEN

PHOTOGRAPHY BY KIM LIGHTBODY

quadrille

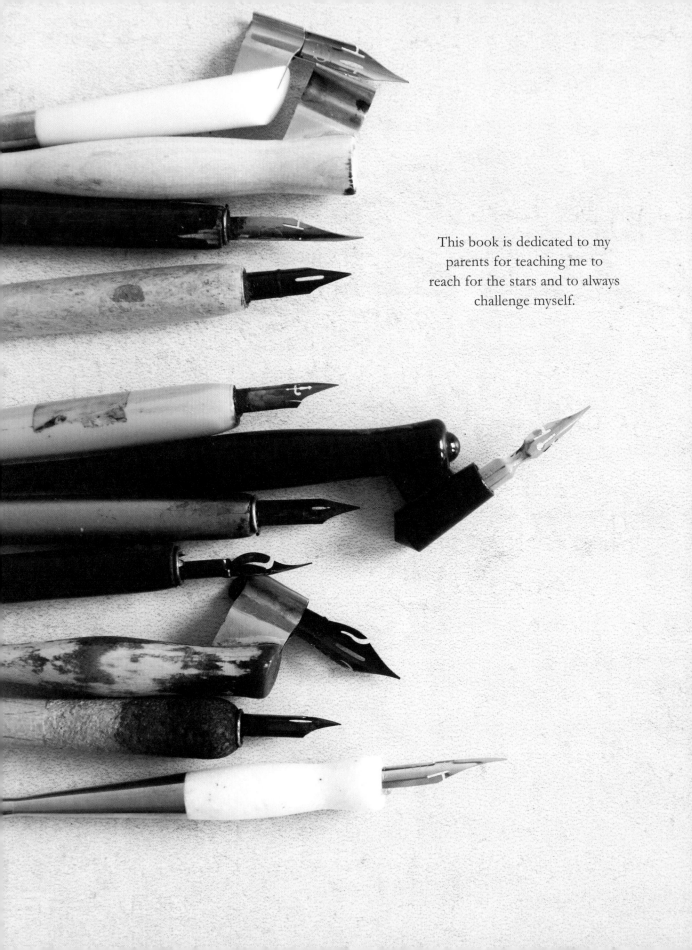

This book is dedicated to my
parents for teaching me to
reach for the stars and to always
challenge myself.

CONTENTS

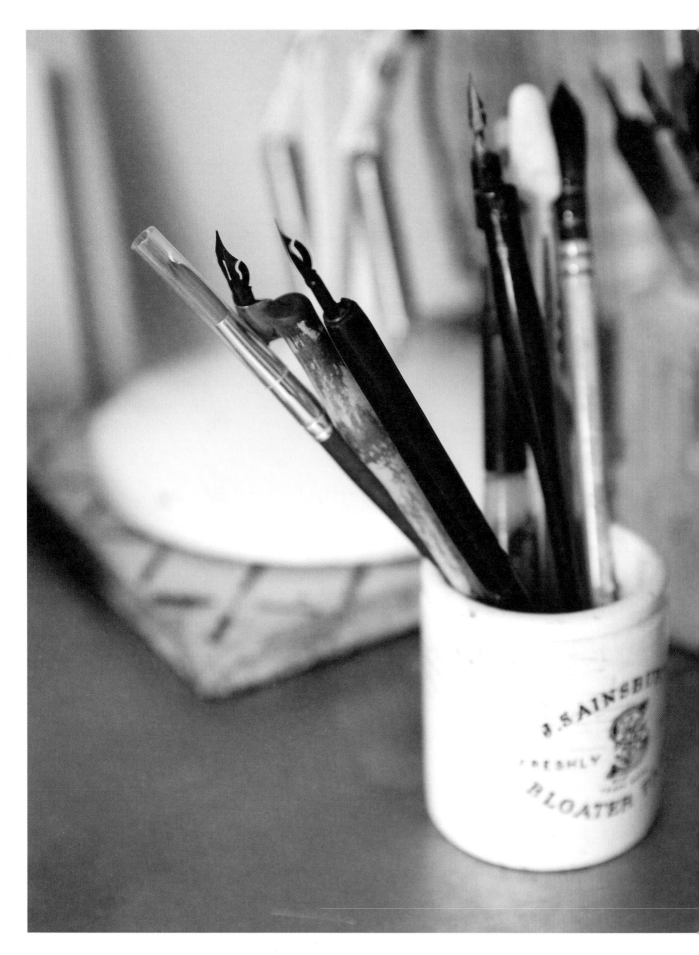

INTRODUCTION

In 2013 I launched my stationery brand, and the more obsessed I became with stationery, the more intrigued I became with the style of calligraphy I kept seeing in the United States. I had loved calligraphy when I was at school, and writing, and loved to write with a fountain pen or my calligraphy pen (mostly in purple for some reason I can no longer fathom). The calligraphy that I was now seeing was so different to anything I'd seen before, and looked so light and elegant. Being an incredibly competitive person I saw my challenge and decided I needed to be able to do this. I looked online at anything and everything I could about modern calligraphy, and Copperplate, and bought lots of different penholders and nibs. I set about starting to figure it out, and was determined to be able to do the beautiful things I'd seen. This was a lot harder than it looked, so I practised as much as I could. It was perfect and utter bliss, something I could do to relax, and I loved it. The more I did it the more I enjoyed it, and the better my work was getting.

When I put my work up on my Instagram account I was thrilled when people liked it. Out of the blue, two different people emailed me and asked me if I'd be able to teach a workshop on calligraphy. I was very flattered and a bit nervous, but agreed to do it. I spent lots of time devising a course plan, and used a lovely friend as a guinea pig to do a test run. I'd seen beautiful-looking modern calligraphy workshops in the US but there wasn't anything in the UK at all. I got all the kit together, taught my first workshops and everyone loved them. I have been fully booked teaching workshops ever since.

I don't profess to be a master of Copperplate, or any traditional form of calligraphy. I've read about and tried lots of different forms of calligraphy, but I developed my style of work on my own, by playing and experimenting. The aim of this book is to teach you about modern calligraphy and hand lettering the way I do things. It's not about teaching you the rights and wrongs of Copperplate; it's about getting you started with what I hope will be a love affair with modern calligraphy and lettering. I hope you find the passion and love of letters that I have and that this book gives you something new to enjoy and make time for, away from the hectic everyday noise of the rest of the world.

Imogen

About Modern Calligraphy

Calligraphy is centuries old and has many different forms and uses. Today, there are lots of amazing calligraphers working around the world in a wealth of different styles and techniques. What I'm going to be talking about in this book is what is referred to as 'modern calligraphy'. There have often been people who have looked at traditional forms of script and who have worked in a more expressive and free way, but the modern calligraphy that I'm referring to is the playful and free development of pointed pen calligraphy.

When I was a child I was always into arts and crafts, be it making Fimo miniatures, creating quilling masterpieces or working on my handwriting and calligraphy. That calligraphy was all about Blackletter, and italics – the stuff of awards and certificates – which I would make for worthy recipients (my mum, dog, rabbit, teddy, etc). I liked to wield some form of authority from a young age, which may have something to do with why I love teaching!

This pointed pen calligraphy is quite a different beast. With those Berol calligraphy pens of my primary school years you could work at a certain angle to create your thick and thin strokes. This is wholly different to pointed pen calligraphy, in which the skill is to become accomplished at varying the degree of pressure with which you apply the pen to the paper.

In pointed pen calligraphy you apply and relieve pressure on the nib of your pen. Applying pressure allows the tines of the nib (see page 12) to split apart and ink to flow between a wider area, thus creating your thick strokes. Your thin strokes are those created by the lightest touch on the paper. Someone accomplished in this makes it look incredibly easy, but this, as with many skills, is something that comes with practice. The great benefit to all this is that calligraphy is a really lovely thing to do – it's relaxing, therapeutic and can be meditative

(although not when you are on a deadline and fast running out of time!). The practice of it is really something to enjoy, and at a time when we spend a lot of our lives staring at a screen, doing something quiet with pen and paper is actually pretty appealing.

Modern calligraphy stems from traditional forms of calligraphy such as Copperplate – a beautiful form of traditional script that looks graceful and elegant and follows fairly strict rules about form and scale and angle. A lot of the more modern work that I'm talking about is practised by people who have studied Copperplate: so that they have an understanding of it, but have chosen to reject some of these established ideas to create an incredibly free, fluid and playful form of script, which becomes far more personal and experimental.

There are plenty of Copperplate resources out there and studying Copperplate will always help to improve your understanding and technique. What I am going to do in this book, however, is to get you started on your modern calligraphy journey and hope that you will go off and develop your work in whichever way is relevant to your aims.

I began to learn and experiment with modern calligraphy myself about three years ago. I had seen lots of calligraphy in the States that seemed very different to anything I'd seen in the UK. There were no courses in the UK so I looked everywhere for source material to work from. I looked at lots of calligraphers, bought some books on Copperplate and watched everything I could. I went out and purchased all the Copperplate nibs and penholders available and I began my trial and error experiments. I practised the strokes, and I tried to copy everything I saw, recreating other calligraphers' styles to try to get a feel for things. Some nibs were horrid, some I loved, and this is how I began to develop. Hungry for knowledge, I looked everywhere to see what different people were doing, how they were experimenting, and tried to be critical about what I liked and what I didn't. This really helped.

This book is my way of helping you to get started and develop modern calligraphy and hand-lettering skills. I do not profess to be a Copperplate scribe, nor is this book intended to give you a traditional grounding in Copperplate calligraphy – there are others far more qualified to do that. As the saying goes, knowledge is power, so if you're interested in modern calligraphy then learn what you can, look at everything you can, try everything, and don't close your mind to anything!

What I teach is how to create something that, while rooted in traditional Copperplate, breaks many of the associated rules and structures and becomes something more playful and experimental. It's about creating something beautifully imperfect, in an expressive and informal way.

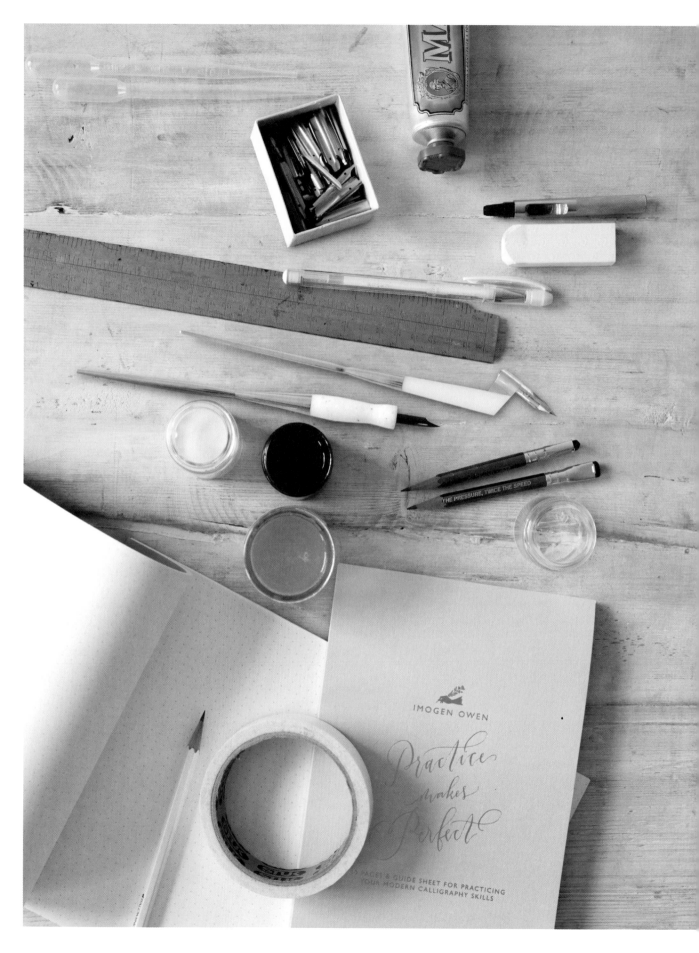

Here I've put together a list of everything you need to get started. Once you get smitten with calligraphy, there are many lovely items you can buy, from the perfect custom-made penholder, to the most lustrous shades of ink. The beauty of learning this skill is that all of the equipment is very reasonably priced. Getting together your basic kit is not going to break the bank by any means!

BASIC KIT

- Penholder
- Ink
- Nib
- Old rag
- Practice paper
- Layout pad
- Pencil (HB will do, but a range
 of artists' pencils are always
 useful, from soft to hard)
- Toothpaste
- Toothbrush
- Plenty of patience
- Cup of tea*
- Biscuit*

PENHOLDERS

To start with, I'd recommend a straight penholder. There are some plastic ones that are pretty cheap and easy to get started with like the Speedball holders, and others that are wooden, some with cork or other grips for comfort. I would recommend buying more than one penholder to see which you like best.

You may well have seen odd-looking penholders, with a strange kinked arm on the side, and looked at these, rather baffled at how and why they should be used. These are called oblique holders. They enable you to write your script on an angle, such as is the basis for traditional Copperplate script. Although they seem strange, and might be off-putting, they are really easy to get the hang of. You will probably find that once you've started using them they will become your tool of choice (see page 21).

Penholders are available rather cheaply so you will probably find that you'll collect quite a few, and keep them to work with different nibs. There are also some rather lovely and beautiful penholders available that are a bit more expensive but can be pretty special. These are usually made from turned wood, or other materials, and come in various designs, with a metal flange to hold the nib which can be adjusted to accommodate nibs of different sizes.

*Ok, so the last two items on the list aren't essential, but you will probably deserve a break from your study.

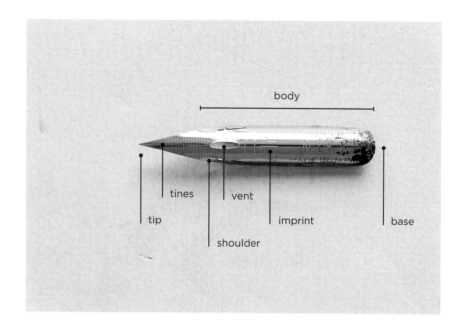

body

tines

vent

tip

imprint

base

shoulder

NIB

These typically cost no more than a few pounds each, so my advice with these is to get a selection and try them out. A Nikko G nib is a great starting point for this style of calligraphy. It's a fairly firm nib, so will yield fine hairlines and lovely thick strokes even if you are a bit heavy-handed starting out. The Zebra G is pretty similar to work with although it can give even finer hairlines. Once you are confident using these nibs, then do try and experiment with others. The nib you prefer will definitely change as you become more proficient. Some nibs you might struggle with at first, may later become your favourites. The more flexible nibs will be harder to use when you start out, as a very light touch is needed. I would advise starting off with the G pen nibs already mentioned, and then try a Hunt Imperial, Leonardt 41, Gillott 404 or Brause 361 Steno (Blue Pumpkin). Some more flexible nibs can give you lovely thick strokes, such as the Brause EF 66, but I'd definitely recommend working up to this nib, as if you've not refined and finessed working with pressure, you'll find it tricky and snaggy.

If you go to a shop or visit an online calligraphy supply store, look for nibs listed for Copperplate. When I started I just bought one of everything, and sorted them into the 'not to use' and 'to use' sections of my toolkit! You'll find some nibs are better on certain paper stocks, and some need a lighter touch than others. It's really worth trying out different ones to find which you prefer and feel most comfortable with.

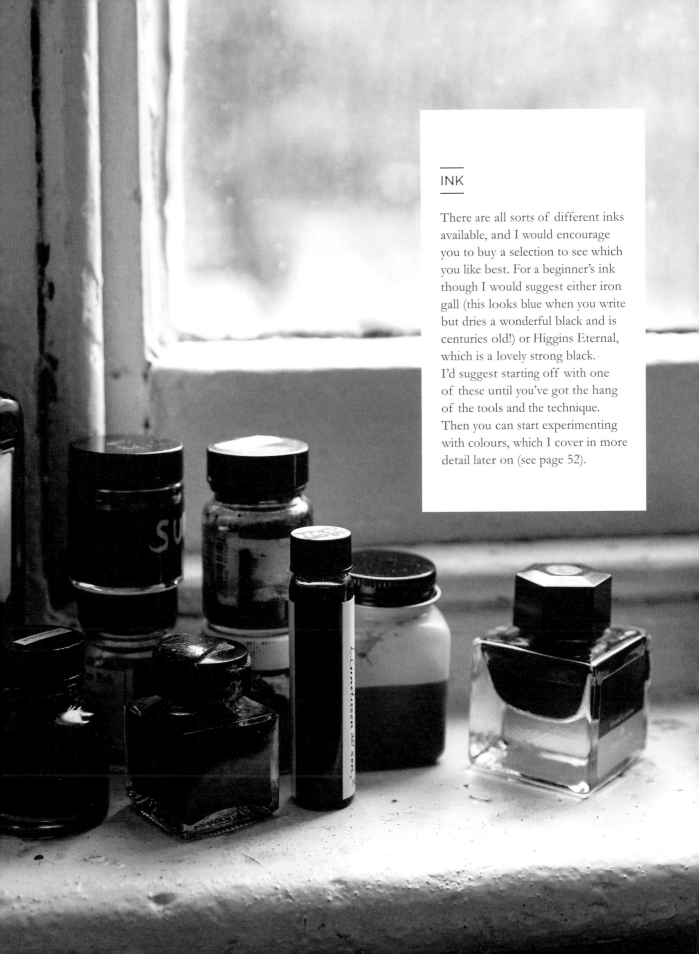

INK

There are all sorts of different inks available, and I would encourage you to buy a selection to see which you like best. For a beginner's ink though I would suggest either iron gall (this looks blue when you write but dries a wonderful black and is centuries old!) or Higgins Eternal, which is a lovely strong black. I'd suggest starting off with one of these until you've got the hang of the tools and the technique. Then you can start experimenting with colours, which I cover in more detail later on (see page 52).

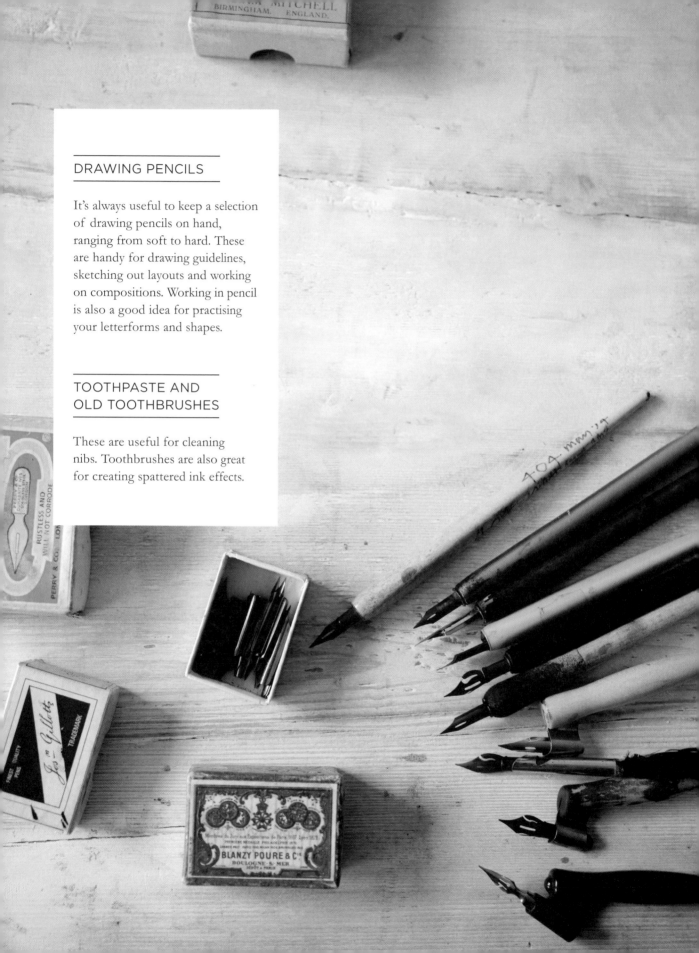

DRAWING PENCILS

It's always useful to keep a selection of drawing pencils on hand, ranging from soft to hard. These are handy for drawing guidelines, sketching out layouts and working on compositions. Working in pencil is also a good idea for practising your letterforms and shapes.

TOOTHPASTE AND OLD TOOTHBRUSHES

These are useful for cleaning nibs. Toothbrushes are also great for creating spattered ink effects.

PRACTICE PAPER

You will need some paper to practise on, and it's not a case of just grabbing some out of the printer tray and cracking on with it. Certain surfaces work better than others, so although you can buy sheets of paper, you don't want to use shiny copier paper, as it's a bad surface to work on.

A general rule with paper is that it needs to be fairly smooth, or you'll find it hard to write on without a lot of snagging. Something that's laid or with a slight tooth will be much more suitable. Avoid coated stocks as they won't yield great results.

Manuscript do a pretty inexpensive and quite useful practice pad, and I have also produced my own pad, available from my website (see page 141). I've also found some of the Conqueror laid paper pretty good for practising on. A bleedproof layout pad will also be super useful: this is a thin paper stock that you can use to trace over letterforms, which gives a nice even result without bleeding and can be used later to develop your own work further.

Bristol board is good for finished pieces and is good to scan for digitizing work. Rhodia pads are also great for practising on, and come lined or plain. Even if you've seen calligraphy with lovely textured handmade Khadi paper on Pinterest I'd stay away from this until you're more confident, as it is tricky to work on. As with textured paper watercolour, you need a hot-pressed finish (which is smoother) or it really is hard work.

OTHER USEFUL EQUIPMENT

INK/PAINT JARS

It's really useful to have a selection of containers for keeping mixed inks in. You can buy little plastic ones pretty easily with flip-on lids, or small glass screw-top ones (sold for the cosmetics industry) are pretty useful. Choose ones with a wide neck so you can easily dip your nib in them.

DISTILLED WATER

When mixing ink colours or diluting inks, it's preferable to use distilled water instead of tap. This is really easy to pick up, and is very cheap for a pretty large container. Look for it with car things in the supermarket, DIY store or in car accessory stores. See also page 56.

PIPETTE/EYE DROPPER

This is the easiest way of adding water to inks to dilute them. These are very cheap to pick up and can easily be found online.

MASKING FLUID

This comes in really useful for working with resist techniques, as you can mask an area to be revealed later. I'd recommend the Winsor and Newton one. I've tried some cheaper ones and they are not so good. This can be applied with a paintbrush or used with your nib instead of ink. See also Watercolours.

GUM ARABIC

This can be bought as crystals to be made up yourself, but most art shops will sell it in liquid form in a bottle. This is really useful when mixing your own inks, and also to improve the flow of ink.

GUM SANDARAC

This can be found in lumps that need to be ground, or a ready-ground powder. It can be used to help improve a surface for writing, for example if a paper is very absorbent and the ink is bleeding and feathering a lot.

PAINTBRUSHES

A selection of paintbrushes is always useful. Wide flat brushes are useful for painting colour washes on papers. A range of finer pointed brushes are useful for lettering purposes as well as for mixing gouache and other ink colours and loading inks onto your nib.

SHARPIE PENS AND ACRYLIC MARKERS

It's always useful to have a selection of these. Sharpies and Posca pens are my favourites in black and white, and I have a selection from fine-tipped to bullet point. These markers are great for faking calligraphy and hand lettering. The metallics are really good and show up brilliantly on dark paper or other surfaces.

TAKING CARE OF YOUR KIT

When you've finished working, it's always a good idea to take out your nib from the holder and give it a good clean to keep it from rusting. You can use a pen cleaner, or a bit of toothpaste on an old toothbrush. Dry your nib and keep it safe. Always clean up when you've finished working and put lids tightly back on your inks.

GEL PENS

A fine gel pen in white or other light opaque colour can be great for working over thick ink lines to add detail or textures.

MASKING TAPE

This is always useful to have for masking areas, or holding things in place, as it will come away without tearing paper.

SCALPEL/CRAFT KNIFE

I always have a scalpel handy, as well as spare blades. It is perfect for making clean cuts, and can also be used to help save a piece of finished work from unwelcome ink. You may find that small errors can be rescued by careful use of a sharp scalpel, to gently remove some of the paper surface, and a rubber to carefully remove any trace of what you've done.

WATERCOLOURS

A good set of watercolours is a great addition to your toolkit. As well as being able to use them to paint with to create lovely illustrations to go with your calligraphy, you can also use them to great effect when brushed over calligraphy created with masking fluid, or to decorate areas that have been masked off.

GOUACHE AND ACRYLIC PAINTS

These are great for mixing custom colours, and create brilliant opaque shades to work on all manner of coloured paper stocks. Pick useful colours with which you will be able to mix a wide variety of shades (but feel free to be seduced by the delicious neons and metallics too!).

HOLE PUNCHES

I recommend a hole punch that you use with a hammer rather than a regular office hole punch. These are available in art and craft stores and will punch holes in a variety of materials. These are super useful for making holes in gift tags, for example, as they offer much more flexibility in size than a standard hole punch.

RUBBERS

A choice of rubbers is always useful. Kneaded 'putty' rubbers can be useful as you can shape them and they are good at getting rid of pencil lines. I keep these, but they can smudge your work, so can be a mixed blessing. Don't think that a dodgy pink rubber on the end of your pencil will do as it really won't. I find a good-quality white Staedtler rubber tends to work well for most things; or the retractable type ones are good too.

Setting up your Workspace

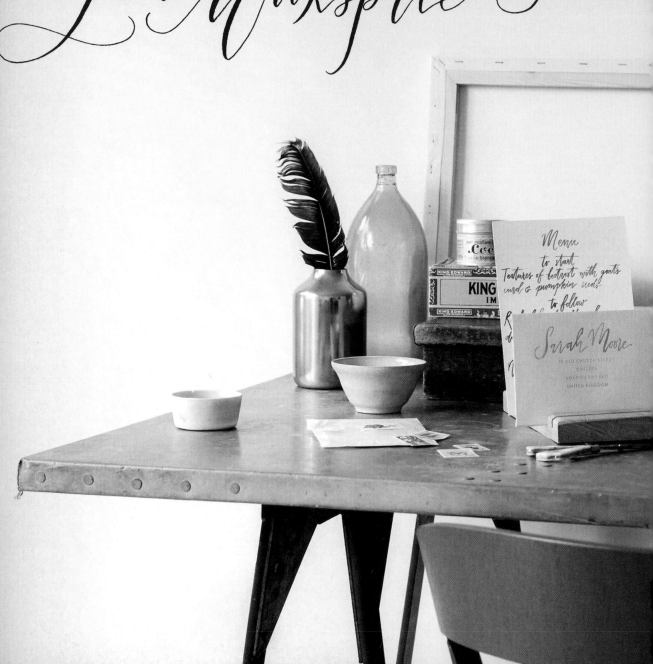

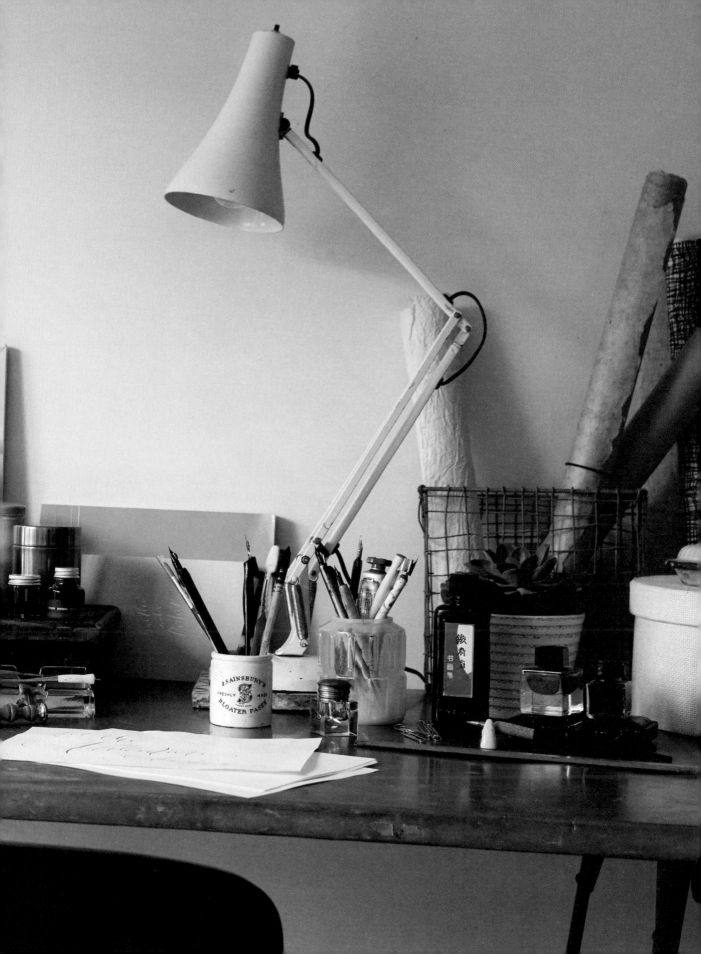

Of course, you will need to have some table space or a desk for your calligraphy practice. Be aware that you will probably churn out a fair few pages of inky paper, so you'll need somewhere to put these too. If you've got a table at home you can work at, make sure you've eyed up somewhere to put all your experimental pages to dry. You may get a little inky, or have some spillage, so if it's a precious table or surface then put down something to protect it.

You need a comfortable chair to sit at, so you can sit with your back as straight as possible. You don't want to end up hunched over with your face virtually in your calligraphy work!

I'd recommend putting a few sheets of paper under the one you are going to be working on, as this will provide an easier surface to work with. You may want to get a clipboard to work on; this will also be useful if you have anything you want to trace over or work over. You'll need some water to wash your nib in, a rag or old cloth to dry and clean your nib on, and your ink. Lay everything out so that it's to hand. Be careful not to place your ink somewhere that you are likely to knock it flying while working!

tip

DIY INKSTAND

You can buy inkstands, but a cheap and easy way of making your own is to get a bath sponge (not a real natural sponge but a cheap synthetic one), put your ink pot in the middle of it and draw around it with a marker. Cut out the sponge inside the marker lines, so your ink pot will fit snugly into the middle of the sponge. This way the ink won't be able to tip over, and the sponge will soak up any ink drips from around the jar.

GETTING STARTED

No pressure – well some, actually! The key to this style of calligraphy is to understand the use of pressure on the nib. The first thing to do is check that you're holding it correctly. Some straight penholders have cork grips, some are totally straight and some have little ridges to help show you how to hold them. You need to hold the pen lightly between forefinger and thumb, as pictured. It's important to hold the penholder in the correct way, in order to be able to make the most fluid and free movements with the lightest touch; as holding it incorrectly can inhibit your movement or make it harder to vary pressure easily. This may be different to the way in which you normally hold your pen or pencil. If you grip a biro in your fist and write with it so forcefully you make exceptional braille, just be prepared that it might take a little while to get used to a lighter touch. It's very common to have picked up some bad habits along the way since your school years.

Make sure that you aren't gripping the penholder very tightly. This really isn't necessary and will result in what I call 'calligrapher's claw' where you've been holding on so tightly your hand aches and your fingers go stiff. Calligraphy shouldn't be painful!

When you're working you need to keep relaxed, so that your arm moves freely and not just from the elbow. You need your arm to be nice and loose in order to move comfortably across the page and to form your letters and flourishes as freely as possible. Make sure you sit properly with your back straight and don't hunch over your desk.

SO NOW WE'RE READY TO GET STARTED...

Dip the nib in the ink, submerging it so that the little vent hole is covered. Wipe off excess ink from the underside of your nib on the rim of your ink pot, so you don't drip across your paper. Then you are loaded and ready to go. To start with, it's all about getting to grips with some practice strokes. To create your thick downstroke you need to place the nib on the paper and exert enough pressure for the tines of the nib at the end to splay slightly, and pull down to make your stroke. Practise this and see how you get on. Now for the upstrokes. For these you want the nib to be just touching the paper and then to push the nib up. Don't be alarmed if your upstrokes are a bit wobbly – that's perfectly normal for starting out. You will need to practise control – I promise this will come.

What you are looking for here is to be able to get a nice super-thin line, and then a lovely contrasting thick line, so we have a great balance. To start with, just practise creating these straight strokes up and down, thick and thin, so you can get a feel for the difference in pressure.

Work on creating your up- and downstrokes. Start by practising vertical lines, like the ones at the top of the facing page. Once you've mastered this you can move on to try the shapes below… Once you've got to grips with going up and down, work on joining the strokes together to create zigzag shapes, applying and relieving the pressure gradually. Move on to practising more fluid curves, following the shapes opposite. Follow the arrows, and remember that the strokes you make going down are your thick strokes, and those going up are thin strokes.

THEN...

When you've had a go at these you can move on to the shapes on page 24. These are going to help you with forming the letters later on. All the letterforms you will be working with will be composed of different shapes and curves.

This is a new skill, so be patient: the more you practise, the more intuitive it will be. Eventually it will become part of your muscle memory, so that adding and relieving pressure is something that you don't even think about – you just do it!

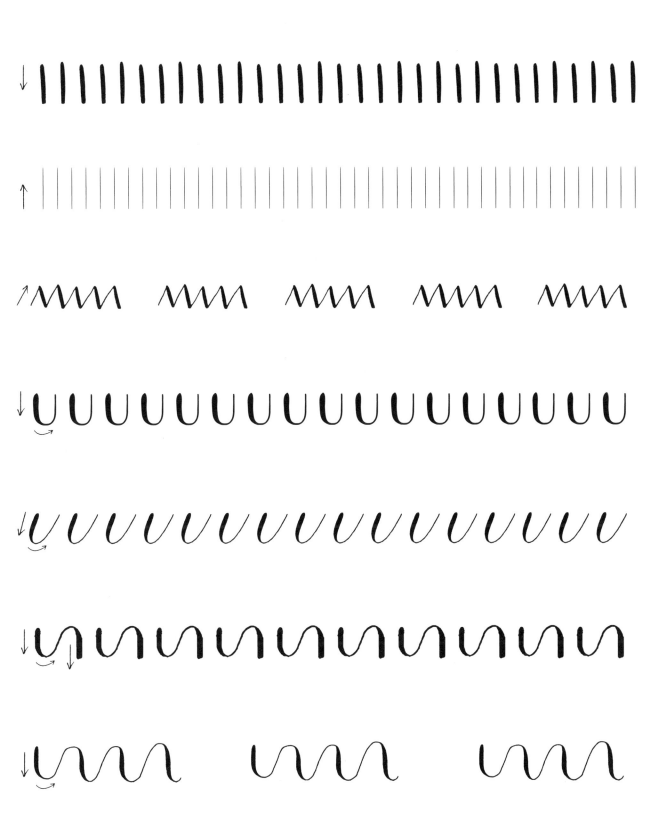

C C C C C C C C C C C C C C C C

@ 0 0 0 0 0 0 0 0 0 0 0 0 0

0 0 0 0 0 0 0 0 0 0 0 0 0 0 0 0 0

≈ ≈ ≈ ≈ ≈ ≈ ≈ ≈ ≈ ≈ ≈ ≈

7 7 7 7 7 7 7 7 7 7 7 7 7 7 7 7 7 7 7

l l l l l l l l l l l l l l l l l l l

ſ ſ ſ ſ ſ ſ ſ ſ ſ ſ ſ ſ ſ ſ ſ ſ ſ ſ ſ

PRACTICE MAKES PERFECT

Consistency is key! Try and work on getting the same result every time. You are trying to make controlled, accurate forms on the paper. Once you've got to grips with adding and relieving pressure fluidly around a curve you can put this all together to create oval forms. Coming back to these exercises will improve your stroke quality.

How should it feel? When making your thin or hairline strokes, you want to feel as if you are just lightly 'kissing' the paper. The lightest of touches is all that is required here. If – like me – you tend to be heavy handed, just think even lighter still! Your thick stroke should then just be adding a touch more pressure to this.

Not sure if you're doing things right? Look down the length of your pen. Your nib point and vent hole should be at the top, so you can create a nice thick stroke. If your nib is turned to the left or right and on its side you will encounter resistance so you can't create your downstrokes easily – you will hear the resistance in the paper. An easy way to check this is to look at the weight of your stroke: is your stroke thick when you are coming down or is the thickness all at the bottom?

Remember, the angle at which you use the pen stays the same, so don't be tempted to turn it around curves and corners!

If you are getting nerdly paper fibres stuck to the end of the nib, that's a sure sign that you are pressing too hard, so ease off. Depending on what kind of practice paper you are using you can also feel of the underside, if it seems as if you have made an intense new form of braille, then you are probably pressing too hard.

There is no shortcut to learning calligraphy – practice really does make perfect, and you'll always find there are ways to improve on what you've done. Always be prepared to learn something new and develop – you'll get so much more out of it that way.

When you make an oval, picture a clock face. Start at 12, and then go anti-clockwise down to 11 and start gradually applying pressure, relieving it again by 6.

If your stroke is jagged, check the angle of the nib. If you're not at the correct angle the tines of the nib won't split properly and you won't be able to get a smooth downstroke.

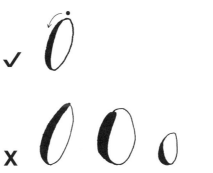

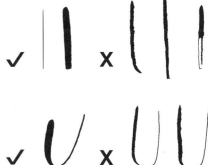

Letterforms

You've practised forming the basic shapes and got an understanding of how to vary the pressure on the nib. Now it's time to start looking at letterforms. The easiest way to start is to get a feel for the letters by tracing over them. You'll need to use your layout paper for this exercise.

STEP 1

Using bleedproof layout paper, or tracing paper and a pencil at first, try tracing the letterforms on the following pages. Even when using a pencil you can still practise adding and relieving pressure. This will help you get a feel for how the letterforms are created. Follow the arrows (see opposite) and note the order of the strokes as to which are made first, second, etc.

STEP 2

Now using your layout paper, try to trace the letterforms again, this time using the pen and ink. Remember to follow the arrows and make the strokes in the correct order.

STEP 3

Go it alone. Look at the letterforms and practise copying them, without tracing. Keep repeating and work at getting a consistent result.

Tip

DON'T BE TOO HEAVY-HANDED!

Layout paper is a thin paper stock; if you are too heavy-handed you'll find you go through the paper, or dig in and pick up paper fibres. Think about how lightly you can apply pressure and you shouldn't have any problems.

The second stroke is the downward stroke where more pressure has been applied.

Start at the dot. In this case, the first stroke is the lightest stroke on the page, going up.

Your letterforms are constructed from a series of strokes. This letterform has been constructed in three stages. These strokes are made in a certain order and combine variations of the basic shapes we've been practising in our warm-up exercises. You don't have to keep your pen on the paper and do it all at once; you can stop and lift the pen from the paper after each stage.

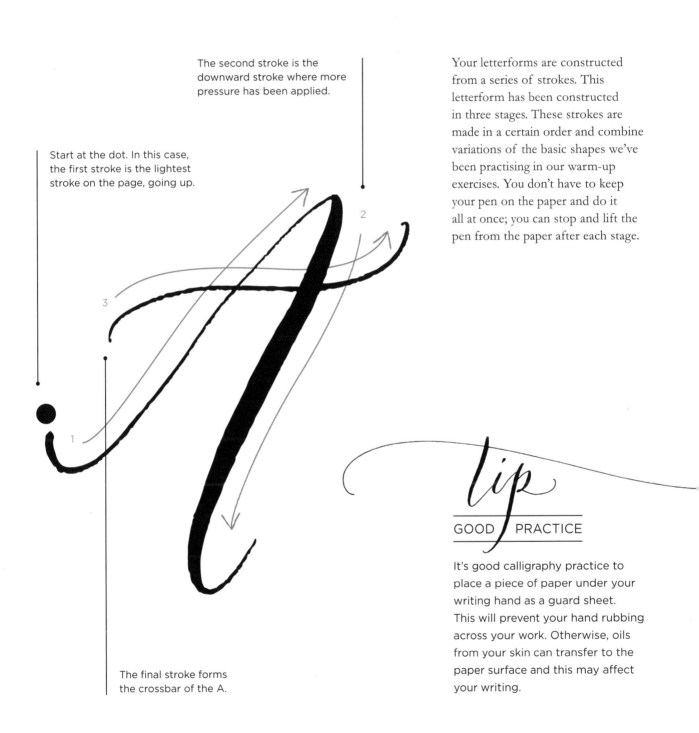

The final stroke forms the crossbar of the A.

Tip

GOOD PRACTICE

It's good calligraphy practice to place a piece of paper under your writing hand as a guard sheet. This will prevent your hand rubbing across your work. Otherwise, oils from your skin can transfer to the paper surface and this may affect your writing.

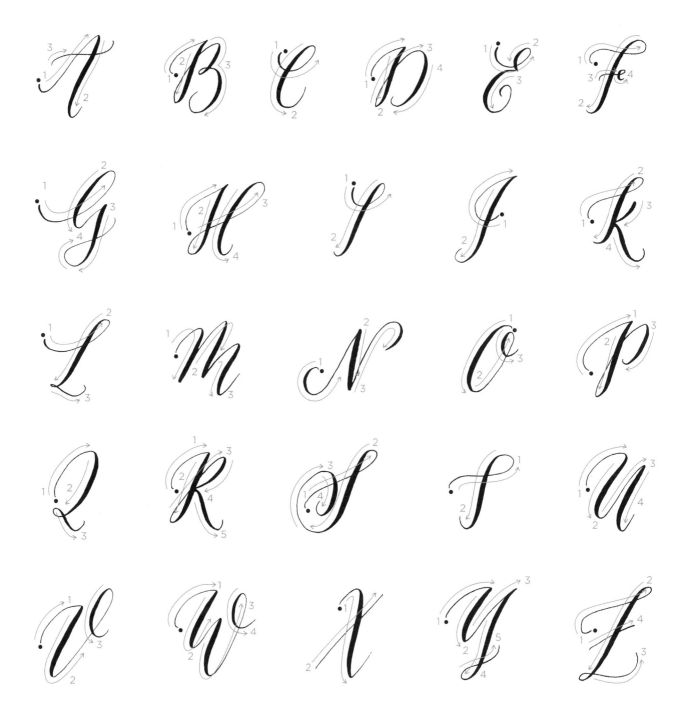

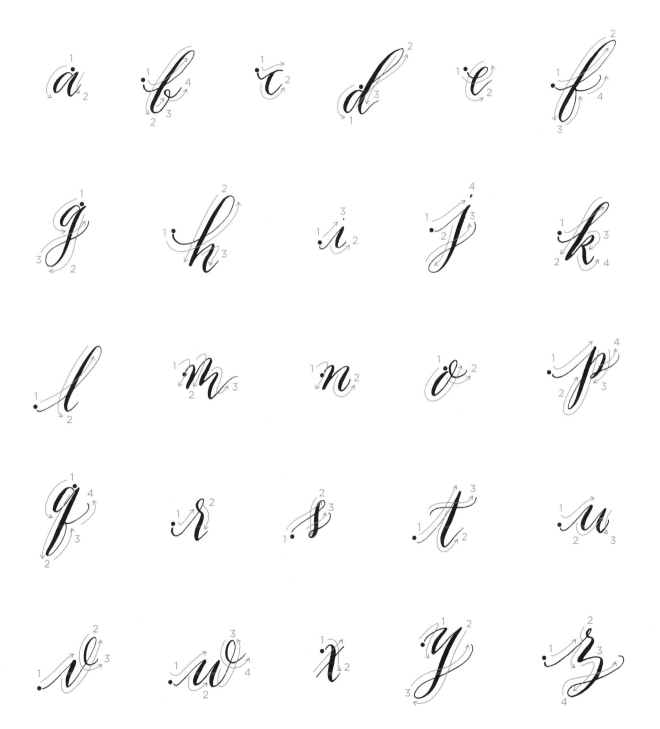

COMMON MISTAKES
AND HOW TO SPOT THEM

Looking at your letterforms, if when you've applied pressure the thick part of your stroke is not down the shape but at the bottom or the top, you've probably got your nib at the wrong angle. It's not facing up, so make sure you've got a clear line running down the pen.

If there are jagged edges on your thick strokes, think about your pressure, and watch the angle at which you're using your nib. If you're getting a lot of resistance that is preventing you from creating a lovely fluid stroke, then try and ease your pressure. Also make sure that you're not dragging the pen sideways, but pushing it up or pulling it down.

Some people find themselves twisting the pen around without even knowing they're doing it. It can be a good idea to put a mark on your penholder with a bit of nail polish or something so you can line the nib up when you insert it, and keep an eye on it, making sure that you can always see the mark.

THICKS AND THINS

KEY POINTS TO REMEMBER

- Your thick strokes are always made coming down.
- Your thin strokes are always made going up or across.
- A thin line can cross another thin line.
- A thin line can cross a thick line.
- A thick line should not cross another thick line.
- A good example of this is a capital 'A'. The crossbar of the 'A' should be a thin line not a thick one, as it is crossing a thick and a thin line.

tip

I always advise people when they are starting out to keep what you've done or make a record of it, as it's really useful to see how far you've come and how you've progressed. It's such a satisfying experience and it's great motivation, especially if you are feeling a bit negative. It's often the case that you haven't really taken in the achievements and progress you've made.

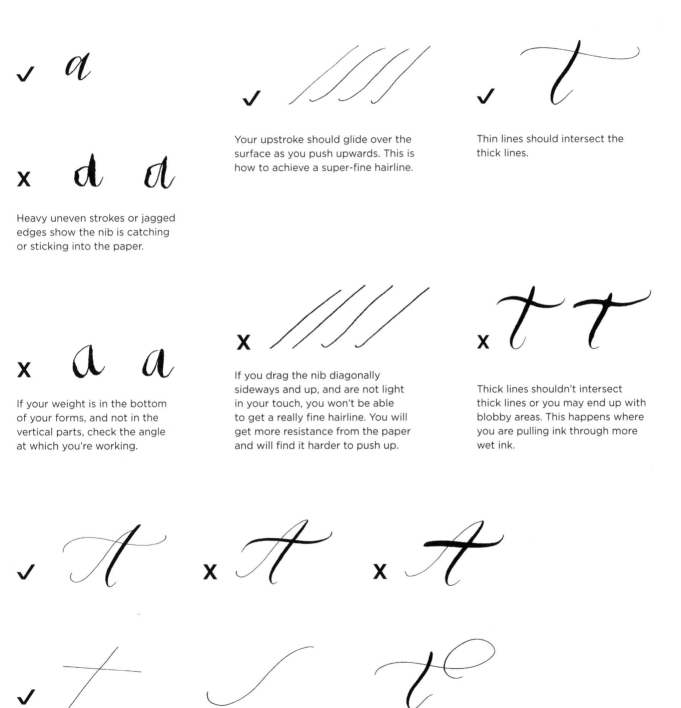

Heavy uneven strokes or jagged edges show the nib is catching or sticking into the paper.

Your upstroke should glide over the surface as you push upwards. This is how to achieve a super-fine hairline.

Thin lines should intersect the thick lines.

If your weight is in the bottom of your forms, and not in the vertical parts, check the angle at which you're working.

If you drag the nib diagonally sideways and up, and are not light in your touch, you won't be able to get a really fine hairline. You will get more resistance from the paper and will find it harder to push up.

Thick lines shouldn't intersect thick lines or you may end up with blobby areas. This happens where you are pulling ink through more wet ink.

PUTTING IT ALL TOGETHER

So now you've had plenty of practice forming letters it's time to put it all together.
Start by breaking down words into smaller parts.

Work on pairs of letters, so you get used to how the entry and exit strokes work and the connections between the letters, in particular how these change and relate to each other. If you break words down like this it's also easier to identify which parts you might find harder and to work on them so that when you join them together the result is harmonious.

Practise forming pairs of letters, especially any combinations you find tricky. I've included some examples on the facing page of some of the more difficult letter combinations.

So now there is nothing to stop you, find anything you like and copy phrases or text and just keep practising. Once you've chosen a word, break it down into different letter pairs, and then small groups. Make sure you practise each letter joining to the next, so you feel comfortable moving between the characters.

Start small and then you can get more ambitious. Really take time to look at the letters that you are making, the balance of them, the space between them, and concentrate on getting an even and consistent result.

tip

SPACING

A good tip for how to space between words in calligraphy is to think of a space taking up the same room as a regular lowercase 'm'. Bear this in mind when you are looking at the space between words.

The lowercase 'r' can be a particularly difficult letter to get used to. Make sure you elevate the little loop, as this helps to keep it legible. If it's too low, it can read like another letter and become a bit muddled.

uu uu uu uu uu uu

ae aa ee be be

fo ll mn op oo

or pp pp qu rr

ry th tr tt

lo ov ve ly lov ely

UNDERSTANDING PROPORTIONS

With my calligraphic style, I've never been too hung up with guides and structure, but it's good to get an understanding of the proportions of letters. When you then break and abuse these rules while developing your own style, you will have a point of reference, and may find this helps with your basic letter formation. Some understanding of Copperplate will always come in useful, and there are plenty of resources specifically on Copperplate.

If you study typography at all you will find that there are very specific relationships to letterforms and their height, space, weight and so forth. This is no different in calligraphy. With Copperplate there are specific ratios for the body height of your letters (that's the height of the a, c, e, o and the body part of the d, g, h, etc) and the comparative height of the ascenders (the tall bit that goes up on the d, h, k, l, etc) and descenders (the bit that goes down on the g, y, p, etc). On the facing page, I've illustrated some guides set to a typical Copperplate ratio. These are marked with an X for the body of the letters, the baseline (the line upon which all the letters sit), an A for the ascender height, and D for descender height.

Getting a feel for these proportions is good practice and using guides will help you to get used to achieving a consistent result and even spacing. If you buy a calligraphy practice pad, these are the lines you will see. However, don't get too attached to these guides: what you are aiming for is a style of script that is much more free and less rigid. My work has a moving baseline so it varies quite a bit; I also like to play with scale.

This is the height for the ascenders (A) of your letters – the top of your h, l, k, etc.

This is the baseline for your letters to sit upon. The line above makes the height of a lowercase x (X).

A

X

D

This is the length for the descenders (D) of your letters – the bottom of your g, p, y, etc.

Work on consistency, so that all of your letters are at the same angle, and evenly spaced. Getting this established will provide a great foundation for whatever style you adopt.

Pay attention to your ascenders and descenders. Make sure you fully extend them, or your letterforms will become short and squat.

The guidelines are a useful way to get a feel for the ratios and form of your letters.

1 *lovely*

2 *lovely*

3 *lovely*

4 *lovely*

5 *lovely*

6 *lovely*

7 *lovely*

8 *lovely*

YOU GOT STYLE...

Whether you've got the wedding of the year to orchestrate, a cupboard full of jam you want to write labels for, or simply want to create the loveliest snail mail a postman ever laid eyes upon, what I really want you to take from this book is the knowledge and the ideas to go ahead and create your own unique lettering style, and to have fun and be able to enjoy something that gives me such great pleasure.

DEVELOPING YOUR OWN STYLE

So far we've looked at the proportions of letters and how to form letters (and words) with thick downstrokes and hairline upstrokes… so now make it your own. This is the fun part – be experimental! You've tried out some of my letterforms on the previous pages but how to develop your own style? Compare examples 2–7 on the facing page with example 1, which is your starting point.

- What happens if your letters don't all sit on the baseline? What if they float above or below it (2)?
- Play with the scale – what if your letters jump between different scales and sizes (3 and 4)?

- What happens if you elongate the curves (5), or when you reduce them (6)?
- What if your ascenders and descenders are exaggerated and extended to be tall and spidery (7)?
- What if you elongate and exaggerate the space between letters (8)?
- What happens when you write quickly? What happens when it's slow? What kind of forms come more naturally to you?
- Try different things and think about what comes naturally to your hand.

There are many ways to play and experiment, but the key is to develop your own unique style. This will also evolve and change, but that's part of the beauty of it. Some things you try will look really beautiful and some

may just look odd and wrong but it's all about developing a style through experimentation and seeing where it takes you.

Feel free to experiment until you fix on a style that comes naturally to you, and then work on all the letterforms. You want your work to be consistent; if your style is quite sparse having some random letters that are really over the top will probably jar, so make sure all your forms are harmonious, and that the letters sit together.

Although this is an experimental calligraphy hand, try not to just revert to your natural handwriting, and think carefully about the forms that you make.

tip

If you have studied Copperplate or traditional calligraphy, much of this will go against what you've learnt. If this is the case, practise randomly scaling your letters up and down, and over-extending them. Break all the rules you've been trying to stick to!

SIMPLE SOCIAL STATIONERY

One of the nicest things to do with your new-found calligraphy and lettering skills is to create beautiful snail mail. No one ever remarks on the pretty email they just received, but getting something really beautiful hand delivered through the post is something else. It's a great way to practise your skills, and to start creating your own style of work.

Amy Marcus
11 Regent Row
Cambridge
CB1 6PS

It's a good idea to type out the address of your recipient out, and centre it so you can see how much space each line of text takes up, and line up your work accordingly.

For envelopes you can easily make your own template, or just mark up the envelope you are working on.

You will need to mark out the middle of the envelope, work out how many lines of text you need and mark these out and, most importantly... **leave room for the stamps!**

Envelopes are a great place to test out your creativity, and a drawer full of pretty stamps is always useful. You can also find vintage stamps online.

You can be minimal and simple, or add hand-painted embellishments, or stickers, or even glue on vintage paper ephemera or Victorian scraps... One thing is for sure: whoever is the recipient of your creative efforts, they will be thrilled when it comes through the post.

On the next few pages I've provided some different examples of ways to plan out your own envelopes. Once you've mastered the idea behind a basic layout, there are lots of ways you can add some serious style to your envelope.

tip

Remember to think about the space between your lines of text. You don't want your ascenders and descenders crashing into each other because you've not left enough space!

Work out the maximum line length you'll need.

Allow space for whatever stamps you'll need, bearing in mind that if it's going overseas it may need more than one!

Miss Erica Smith
3122 Evergreen Ave.
Charleston
South Carolina
2 9 2 9 0

Mark the middle of your envelope if you want your address to be centred.

Calculate the maximum number of lines you'll need, and space these evenly.

tip

Don't draw any pencil marks on your envelope too heavily or they won't be easily rubbed out.

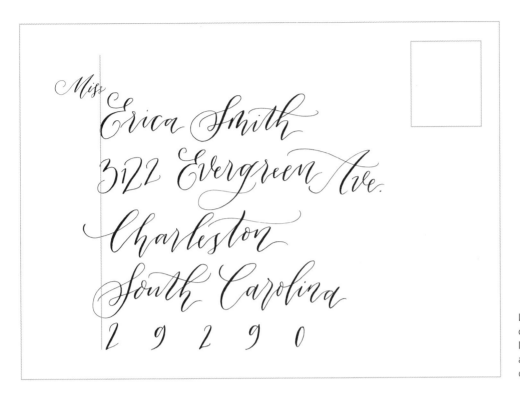

Line up the first characters of each line to align the address to the left of the envelope.

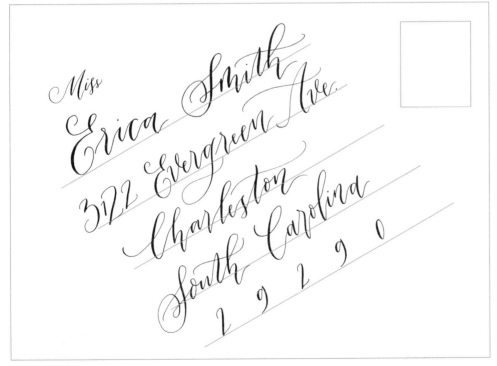

You can create a dynamic-looking envelope by writing the address at an angle – just make sure you still take time to plan it out and line it up.

Sarah Kay
&
Mark Johns

invite you to join them to celebrate their marriage on Saturday 15th July 2017 at Sodo Park, Seattle

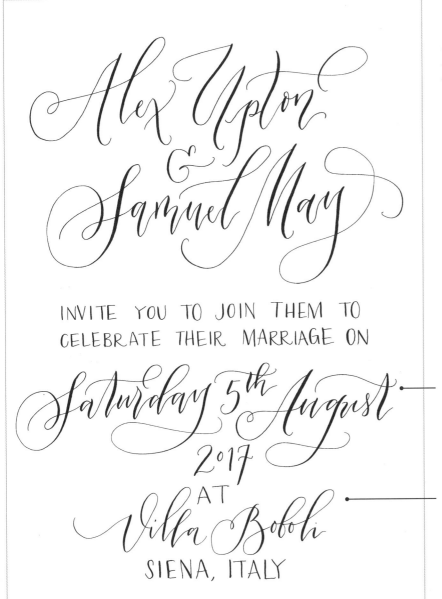

Alex Upton & Samuel May

INVITE YOU TO JOIN THEM TO CELEBRATE THEIR MARRIAGE ON

Saturday 5th August 2017 AT *Villa Boboli* SIENA, ITALY

Once you've mastered the envelope, you'll need something to put in it! Whether it's for your own upcoming nuptials, the social event of the year, or just a simple supper party, show off your skills.

Here is a guide to creating a simple invitation. All you need is a single sheet of thick paper stock and your favourite ink colour.

Keeping the key facts and information as legible as possible. You want to make sure that your invite can be easily read.

Work out the hierarchy of what you're doing, which information you want to stand out, and which is more or less important. Use a mixture of block capitals with calligraphy to great effect, to make the calligraphy really stand out and help with spacing – areas in block caps can take up less space.

CREATING AND PLAYING WITH YOUR OWN LETTERFORMS

Modern calligraphy allows much more freedom to experiment with structure than traditional Copperplate script where there is a right and wrong way of creating your letterforms.

With Copperplate it's all about balance and curves in a very disciplined way. To become proficient in Copperplate is a matter of perfecting this, and also about a level of uniformity, so that every time you create a letter it appears exactly the same (unless deliberately changed with added flourishes). The modern style that I teach is not quite so rigid. Once you have established the structure of a letter it stays the same in essence although it may be varied in size or scale.

There is no single modern calligraphy alphabet that everyone should look at and practise. It's a more personal experience than that. You should be creating your own letterforms with much more of an individual interpretation, and a quite easily discernible style. Let's look at the examples on the opposite page.

A: Just changing the point at which the crossbar of the A appears can totally change the feel of the letterform. If it's in the bottom third of the letter, or the top third, if it is horizontal, if it is at an angle, if it is short, if it is extended – all these things create an entirely different feel.

B: If the bowls and curves of your B are inappropriately small, or the stem is overly long, what impression does that give?

R: Look at how the weight changes the feel of the character; for example, if it's top or bottom heavy.

T: Like the A, the point at which and the way in which your stroke crosses the T changes the feel of the letter. It also gives a different feeling if the stroke is straight or curved.

So play and experiment. How can you change the nature of your letterforms? It's all about working out what's right for you.

Try tracing and looking at the different example letterforms on the following pages to get a feel for different ways of creating letters. The more you do this, the more you will discover what comes naturally to your own hand; then you can start to develop your own letterforms.

LINES AND CURVES

It is very difficult to draw a perfect circle, and far more natural to work with ovals. Think of the oval as a key shape in your work, from the curve of a C, to the opposing curves of an S.

a b c d e f
g h i j k l
m n o p q
q r s t u
v w x y z

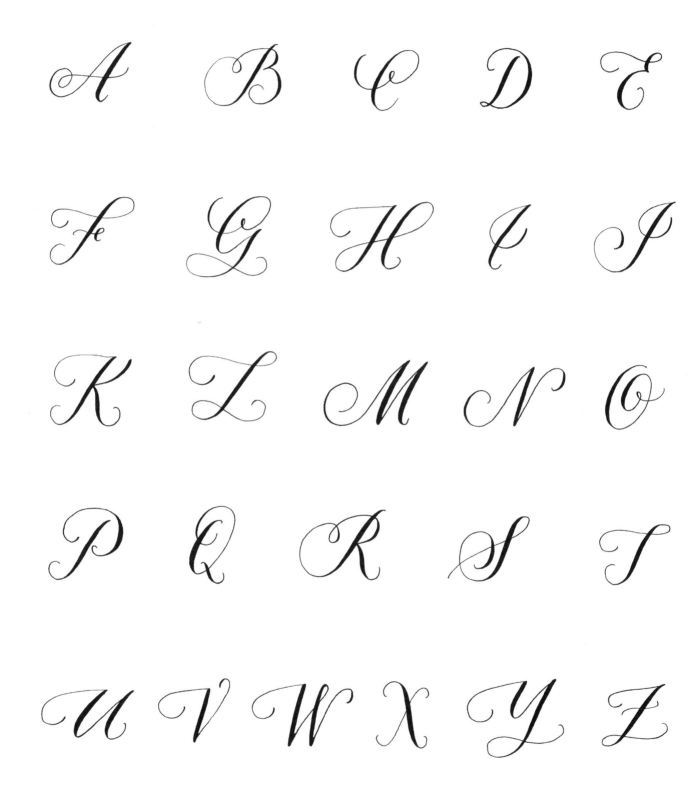

a b c d e

f g h i j

k l m n o

p q r s t

u v w x y z

Aa Bb Cc Dd Ee Ff Gg

Hh Ii Jj Kk Ll Mm

Nn Oo Pp Qq Rr Ss Tt

Uu Vv Ww Xx Yy Zz

Aa Bb Cc Dd Ee Ff

Gg Hh Ii Jj Kk

Ll Mm Nn Oo Pp

Qq Rr Ss Tt Uu

Vv Ww Xx Yy Zz

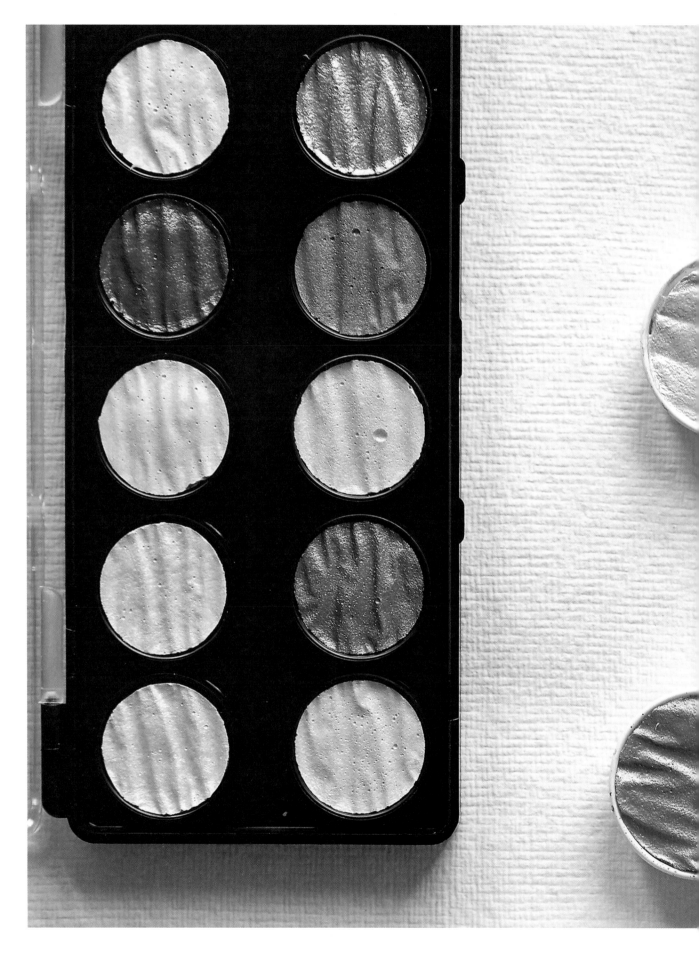

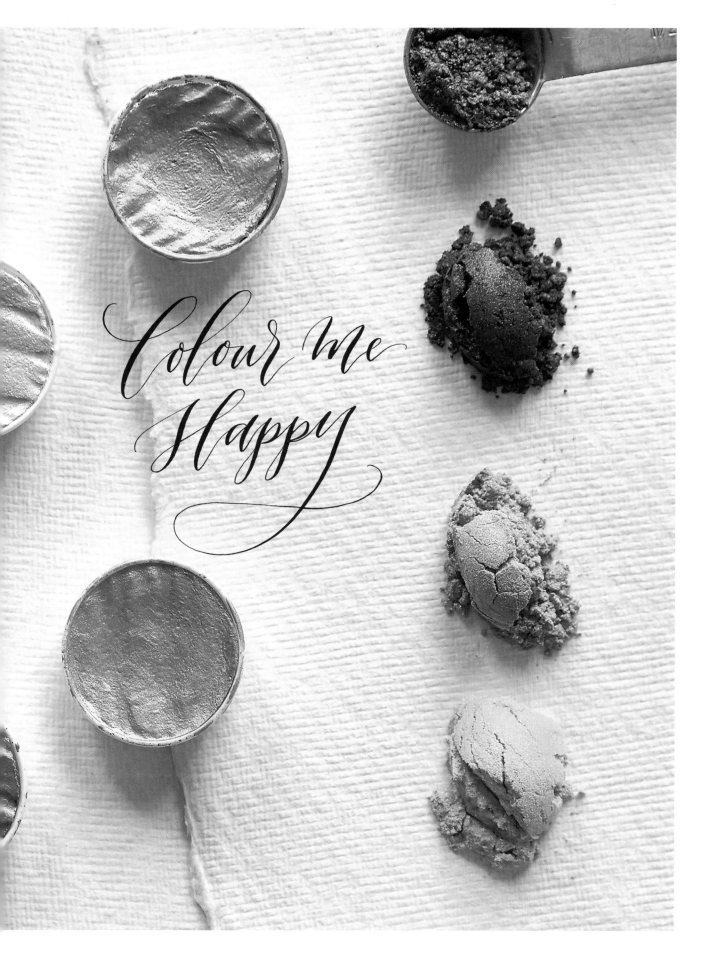

Colour me Happy

There are lots of different inks on the market. I'm going to give you some suggestions on what to use, but I would always recommend that you try out different products for yourself. You might prefer things I don't and vice versa, and it's always best to get firsthand knowledge yourself.

BLACK

Black inks will be pretty well used, so keep a good store. There are quite a few different types of black ink around, and some will work better than others on different surfaces. You may need experiment to find the right comibination. but I find Sumi ink a pretty good staple for most surfaces. See more about my favourite inks on page 13. I tend to decant my ink into a smaller glass jar with a wide mouth, as it's easier to use. Then if you are not working with an inkstand you are less likely to spill a whole pot of ink!

WHITE

There are quite a few white inks on the market – Winsor & Newton and Kuretake to name just two – but my favourite white is Dr. Ph. Martin's Bleed Proof White. This needs to be mixed with water (distilled, preferably) to the desired consistency. Get yourself a little jar or pot, decant some into it and mix it there until it becomes thin enough to work with nicely. Do this gradually – you can always add more water but not take it away!

METALLICS

These are sometimes tricky; they may look lovely in the bottle but the result on paper can be a bit disappointing. Often the trick is to shake the bottle, and keep doing so regularly so that the ink doesn't settle too much. That way, you'll get the best colour and sparkle.

tip
COLOUR MIXING

If you're mixing a colour for a project, make plenty. You might find it hard to mix a second batch in exactly the same shade.

FINETEC

I am pretty besotted with my Finetec palette. This looks like a luscious addition to a girl's eyeshadow collection, but is in fact pans of solid colour that need to be mixed with water (again – distilled preferably) to a workable consistency with a paintbrush. Then you can use the brush to paint the colour onto your nib. This sounds complex but is actually really simple, and you'll soon get used to it. The reward is great colour and opacity and some gorgeous metallic shades.

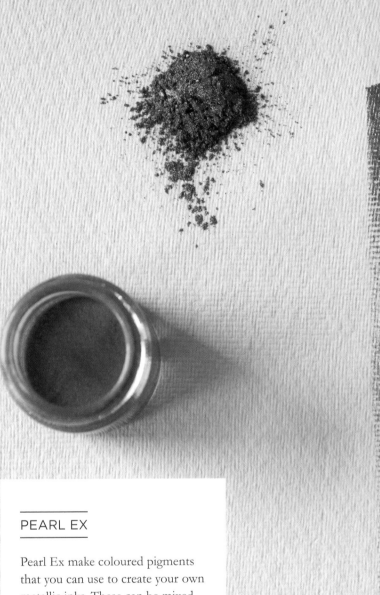

PEARL EX

Pearl Ex make coloured pigments that you can use to create your own metallic inks. These can be mixed with gum arabic and distilled water to the correct consistency. These are a great way of producing your own range of iridescent shades, such as rose golds and pewters and many more. Play around with different ratios – I use one part gum arabic to four parts pigment. Add water slowly with a pipette until you have the consistency you want.

MIXING YOUR OWN COLOURS

There are some great shades around to buy and try. One of the easiest ways to get the exact shade of coral pink, mint green, or whatever else you might be after, is to mix your own inks using gouache or acrylics. If you are going to be working on custom calligraphy jobs it's very likely you will be asked for specific colours to match the client's project.

MIXING GOUACHE

You can buy ready-mixed gouache colours from suppliers, but mixing your own is also pretty straightforward. You need some empty pots, distilled water, and some gum arabic. The gum arabic will help improve the flow of the ink so you only need a little.

Start by mixing the colour of your choice in gouache. Depending on what you are using it for you'll want an amount around the size of a pea/bean. Gradually add water to this until it has the consistency of double cream. You can add a little more water if needed.

When mixing colours with gouache, always add your dark colour to the light colour, not the other way around. For example, if mixing a light blue, add blue to your white until you reach the desired shade. You will use far less paint this way than if you try to add white to the blue to lighten it!

MIXING ACRYLIC

This is a similar technique. Squeeze a length of acrylic into your jar, add your distilled water, screw your lid on very carefully, then give it a good shake until you get a decent emulsion and it's nicely mixed. Check for consistency with the pen and add more water if required.

DISTILLED WATER

What's wrong with normal tap water? In short, nothing. However, over time work created using regular tap water may go mouldy. This doesn't happen with distilled water.

Distilled water is really easy to get hold of, at car supply stores or your local supermarket. A few litres will be very cheap and last for ages. It's good practice to use distilled water, but it's not the end of the world if you don't have any.

You can always add water, but you can't take it away! Add your water gradually so you don't end up with too much…

Tip

CLEAN

When you use acrylic paint it will dry and ruin your nib unless you clean it properly. Make sure you have some proper nib cleaner on hand for when you finish, or when the paint starts to dry on your nib!

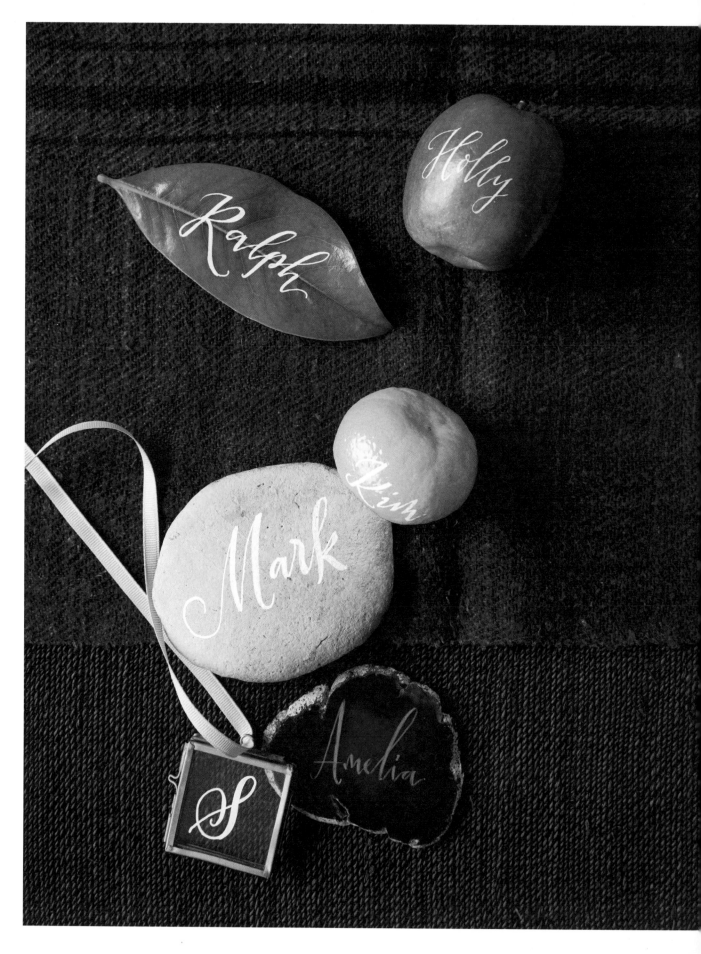

TAKING THE ROUGH
WITH THE SMOOTH

So now you know how to write, what are you going to write on? Why just stop at paper? The great thing about your new skills is that you can translate them onto a wide variety of different surfaces. Some of these you'll be able to work on with a nib and ink; others some will involve some 'faking' of your calligraphy style.

PAPERS

It may sound obvious, but some papers are better than others. Certain papers can bleed terribly, so you really need to try your paper out before embarking on a project. Be prepared to try different inks on different surfaces, as not all ink will behave the same. Acrylic-based inks behave differently to gouache-based inks, sumi ink behaves differently to iron gall, and so on, so it's always best to test whatever material you want to work on with the ink you have for the job.

FLORA AND FAUNA

You can work on different surfaces with a variety of tools. You can raid your garden and find things to write on! Try different leaves and petals and see what works. Firmer, harder, waxy leaves will offer a better surface.

Try using a nib and ink on foliage – pick a nib that's not super sharp as it will be more likely to dig into the surface. If you find you struggle with that, try with an acrylic pen.

You can try writing on all sorts of surfaces, even fruit and vegetables – and calligraphy is a great way to customize your pumpkin at Halloween. Make sure you choose something firm. An over-ripe peach is not advisable!

HARD SURFACES

Polished surfaces such as mirrors, glass or slices of minerals can give a great effect but will not much like your nib and ink. Try with a chalk pen or Sharpie marker and fake it, or use a paintbrush and paint.

You can also try writing on pebbles and stones (the smoother the better), sea glass, mirrors, glass picture frames, windows, or glass hanging decorations – there are so many options!

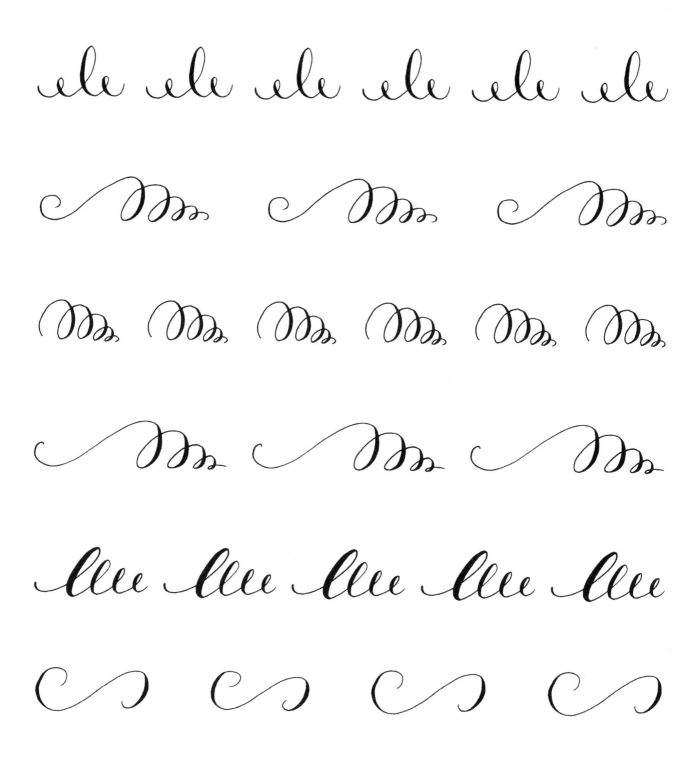

NOW I'M FLOURISHING

This is something that a lot of people struggle with when they are starting out, as it doesn't necessarily come naturally. It's all about practising your curves and fluid transitions, so you can flow from shape to shape.

Calligraphy is all about control – it's important to remember that you control your pen the same way whether you are adding pressure or not. I have noticed when I'm teaching that people take great care and attention to make controlled downstrokes, and then as soon as they start pushing the pen up they just let it meander off and let the line finish wherever, which can make everything look sloppy. You have to decide where your pen is going and take it there with a decisive and controlled action, or your work ends up with a horrid kind of wishy-washy feel, all a bit lacklustre, with badly shaped forms.

Practise your curves, from large to small, and back up to large. Change your scale; be playful and creative. Your work can be minimal or really ornate. Experiment as much as you like; it's all about practice and play, trying out new things and seeing what works. Try to find what works for you with your style.

When adding flourishes to your work, it's important to look at your overall composition. It shouldn't look repetitive. The flourishes should flow and enhance the look, not seem rigid and fixed by being identical on every line. Add balance with opposing shapes and angles, varying scales and direction.

Try the exercises opposite and practise your curves. Trace them at first and then begin to work freehand once you get used to the shapes. You are looking for nice clean curves and getting a flow from shape to shape, with smooth strokes. This is a good test of the amount of pressure you exert on the pen and how tense you are. If you are tense in your shoulder or too heavy-handed and rigid you will struggle to move the pen smoothly across the surface of the paper. The more resistance you meet, the harder it will be to make lovely sweeping arcs and curves. So think light – you want to be free to make beautiful, fluid sweeping movements. Your flourishes can be all lighter thin strokes or you can add thickness in your downstrokes.

Adding flourishes to your work can be a good way of re-inforcing a particular shape. If you are doing a composition within the shape of a circle for example, use flourishes to fill the negative space within this form to emphasize the shape.

There are also lots of beautiful examples of amazing penmanship using flourishes and form to create awesome illustrations of birds, flowers and other shapes. These are composed of simpler flourish shapes used to great effect. Look at the Projects (page 102) for some ideas.

Flourishes are normally constructed in a variety of ovals of varying scale and angles. The more you can perfect your construction of oval forms at different angles the better. It's also important to practise the lines that lead in and out of these ovals, so that you can create seamless flourishes that flow across a page.

Flourishes should always follow on from the natural lines created by your letterform, so they feel like an extension of what is already there. They shouldn't feel as if they are fighting against your letterform.

A smooth line requires a certain level of skill and control. The more you practise, the smoother your line will become. As a beginner, it might help to plan what you want to do in pencil and then work over it and develop it. When you become more confident and proficient it will come more naturally and you will probably prefer to start work straight away in pen.

Make sure you create decisive marks. If you are going to extend a stroke, make sure you control it, so you make a shape that comes to a definite end.

tip

LESS IS MORE

Flourishes work best either on the first or last letter of a word, or on descenders or ascenders. Sometimes less is more: if you have a word that has a 'y' and a 'g' in, you may not want to add flourishes to both. This is all about experimentation, though. You may be someone who loves everything to be flourished and have a really elaborate and ornate style, or you may want to keep things much more pared back and sparse. This is just another enjoyable part of establishing your own style. Remember, never cross a thick line with another thick line, and don't intersect lots of lines in the same place.

COMPOSITION

To work out a composition, you need to look not only at the words that you want to use themselves, but also at the negative space in and around them. Good composition is about being as aware of this negative space as the words themselves. So let's look at how we approach working out a piece of calligraphy...

HIERARCHY

This is really important. Look at the piece of text you want to use. Are all the words of equal importance? Is there something you'd like to stand out more than the rest? What do you want the viewer to take from this? The hierarchy will help give your piece structure and set out the meaning.

STRUCTURE

Is your piece two lines of horizontal even-length text, or does it fit within a shape? A circle, a square, or something more complex? Are the lines of text horizontal or on an angle?

LINE LENGTH

What space would you like your piece to take up? Looking at this space, how long is the longest line? Which words should sit on which lines?

INTERACTION

How do the words interact with each other? What shapes are created within the negative space? How can you use these in your composition? How can you extend letters and add flourishes in a harmonious way using the natural space that is created around the words?

PLANNING

With all this in mind, you can start planning your composition. Start with very roughly drawing out the boundaries of your composition, if, for example, you want it to fit within some sort of shape. Then you can put in any guidelines in for the lines you want the text to sit on. Lightly write your text in pencil so you can see how it fits together and get a feel for how it's going to work. Check to see if there are any areas that aren't working. Have you got any ascenders crashing into descenders and areas that look messy? Or unbalanced areas of space, and then very crowded parts of the design? Adjust all of these so you can get the design to look just right. Then you can move onto identifying areas where you could add extra interest, adding flourishes to your forms.

Happily Ever After

STEP 1

Start with writing out your word or quote. Look at your line length, particularly if you are working around a shape, as you'll need to work the words around this. Look at the hierarchy of the piece. Does anything need to stand out more or less? This example is all of relatively equal importance, so I'm going to keep the lettering quite evenly sized.

STEP 2

Look at how the words sit together and work out a basic composition. I don't think this first example works very well, as it's heavily weighted to the left.

I think this is harder to read, and is confusing. The 'ever' is starting to read as the first word. Be careful about the placement of your words.

I like the roughly triangular layout of this placement, with the 'ever after' nicely balancing out the 'happily' on top.

STEP 3

Once you are happy with your placement, start to develop the piece. Look at where you can extend and flourish lines. Here, I've exaggerated the loop at the top of the r, as I wanted to balance out the end of the 'after'. I've also extended the initial stroke of the A and wrapped it under the 'ever'.

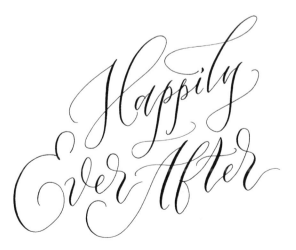

STEP 4

I've got a rough idea of a baseline here, and the composition is still working in a roughly triangular shape.

It's important to be aware of the negative space around your letters, so look at this as well as the shape of your letters. You don't need to fill every available space; allow your lettering to breathe. If you overwork an area it may become quite dense, and will end up becoming the focus point.

I've added interest here by extending and flourishing this p, but I've left the other one as it is. You don't need to flourish everything; make sure what you do enhances the look of the piece.

I've exaggerated this loop in the r even more, as I wanted to balance out the E of 'ever' and the shapes on the left-hand side of the piece.

I've extended the entry strokes on the H and the E to make them more elegant.

There are lots of opportunities to add more flourishes and extend parts of this design. I think this A, f and t could work better together too, as the cross of the t looks a little squashed.

STEP 5

I've identified the word 'after' as an area to develop, so now I'm going to look at the relationship between these letters.

The cross of the f and t is a bit of a conflict area, and needs to be more harmonious. The bottom of the f is an obvious natural line that can be flourished.

Extending the cross stroke of the f so that it also crosses the t works well: it sits at the same height and looks elegant, while remaining nicely legible.

As the A also has a cross stroke, I'd like to experiment with this and see if I can link all three parts together. I think this works.

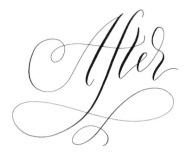

STEP 6

I want to see if I can create a more elegant A and link the entry stroke of the A with the cross stroke.

This looks ok, although the balance of the loop on the left is a bit off – it looks a little fat and squat. I also need to be careful about the spacing between the A and f, as it needs to be nice and even. I'm not sure that the 'ever' works with this style of A; perhaps it's better without the loop.

STEP 7

I've now extended and flourished, and created a more finished piece, using layout paper to work over the earlier lettering stages.

I've tried to make sure that I haven't ended every flourish in exactly the same way or with the same shape.

I've curved parts of some letters around parts of others to help unify the piece.

I've extended some of the letters and flourished them, and I've tried to work within the negative space surrounding the letters.

There are always ways to improve; looking at your work critically is key to progressing. Look at what you've done and think about what works and what doesn't. What would you change? What would you do differently? For me, this piece isn't quite right. I like it, but I think the balance is a little off. Maybe changing the flourish at the end of the y of 'happily', and the way the space is used above the r of 'after' could work better? This would also balance out the flourish of the E of 'ever' on the opposite side. This is all part of the learning process. It's also important to know when to stop. Sometimes less is more.

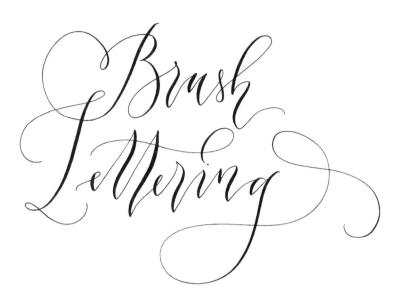

Brush lettering allows you to be a bit more experimental than calligraphy. As a form of hand lettering, it is all about the inconsistencies and happy accidents of the hand made. This is great as you can feel free to mix up scales and lowercase and uppercase letters, and really play with your letterforms. Let loose and really play with the ink. Have a go at creating a looser form of your calligraphy style, or be even freer, and create something bolder and more messy, embracing any ink splatters along the way. Although this style of lettering is really free and expressive, it's always good to try to remember where the thicks and thins occur in calligraphy and lettering.

TOOLS YOU WILL NEED

• Drawing ink or gouache
• Small range of pointed brushes
 and/or Pentel Aquarelle Brush
 pens or similar
• Pot of water
• Practice paper

Pentel brush pens are quite useful as you fill them with ink yourself. I tend to use both these brush pens and a regular brush and ink. You'll need a clean workspace with room for your sheets of paper to dry, as you'll work through your practice sheets pretty quickly.

Winsor & Newton drawing ink is a good black ink to work with, although feel free to experiment with anything you have. Watercolours can be great to work with for this too, as can diluting the Winsor & Newton drawing ink; as the quality of the ink when it's less densely coloured can give really beautiful effects. Try working with a range of brushes to see which you like best and working with the line quality of all of them. Work on the range of line width you can create. What's the thinnest line you can get? And the thickest? Then start to play with forming the shapes needed to create letterforms.

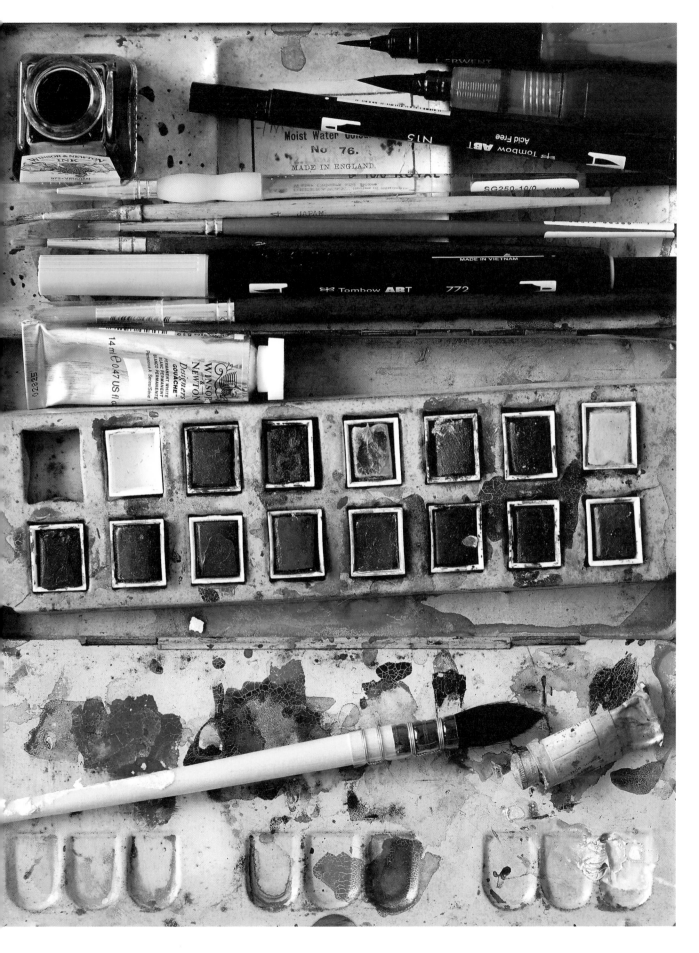

BRUSH LETTERING TECHNIQUE

Start by working through some of the exercises on the opposite page. Trace over them while you get used to using the brush. The key is to be light of hand so you can move easily over the page, as a brush is harder to work with than a nib. You have far less accuracy and precision with larger brushes, so you'll need to practise how to master your curves and changes of direction. These practice forms are a good way of getting you started before you move on to making your letters. The beauty of brush lettering is that it's a lot more forgiving than calligraphy; you may find that you want the brush to start running out of ink, so that your forms are less solid and structured. You might discover you prefer a very heavy thick line, or a fast thin line.

See what results you can get with the tools and then create your own styles. Pace will also make a great difference with this: the letters you make with slow and heavy strokes will be very different to those made lightly speeding across the page. It's another opportunity to play with size and scale too.

What happens if your letters aren't all the same scale? What happens if you have very thick strokes with contrasting thin ones? What happens if your strokes are all the same weight but fast and very free? What happens if you let the ink really run out so your forms are very fragmented but revealing the obvious brush marks? What happens if you dip your brush in water not just ink, so your forms are in mixed densities of colour?

There are lots of ways to play with this. Start to refine the methods that you like best, while you are perfecting your style. The letterforms on the next pages are for you to trace over as a rough guide, or to use as a reference – whichever your prefer. They will show you some of the different styles you can achieve using just a brush and ink.

tip

DIFFERENT STROKES

There is no getting away from it – you will soon find some letters are easier than others, with 'S' being a particularly tricky letter to master. So keep practising and work on the curves. You can always try breaking a letter down into smaller strokes, doing the top and bottom parts in two separate strokes.

A B C D E F G

H I J K L M

N O P Q R S T

U V W X Y Z

a b c d e f g

h i j k l m

n o p q r s t

u v w x y z

A B C D E F G

H I J K L M

N O P Q R S T

U V W X Y Z

a b c d e f g

h i j k l m

n o p q r s t

u v w x y z

A B C d E F g

H i j k (m

N o P Q R S t

y v w X y z

a b c d e f g

h i j k l m n

o p q r s t

u v w x y z

A B C D E F
G H I J K
L M N O P
Q R S T U
V W X Y Z

a b c d e f

g h i j k

l m n o p

q r s t u

v w x y z

life is too
important
to be taken
seriously

OSCAR WILDE

With brush lettering you can be much more free and loose with your work, so embrace the inky virtues of this style. You can keep your lettering clean if you prefer, or use your brush to exaggerate splatters.

awesome

I used the brush to spatter ink over this piece afterwards.

When experimenting with this style, practise constructing your letterforms. You can build them slowly and carefully, or work at speed. Embrace the differences between the two working methods. I (as I'm generally the MOST impatient of people) tend to prefer working loosely and a bit faster and I prefer the result of this. The examples on this page were done more quickly, whereas Brush Letterform 1 on pages 72–73 is a more considered style.

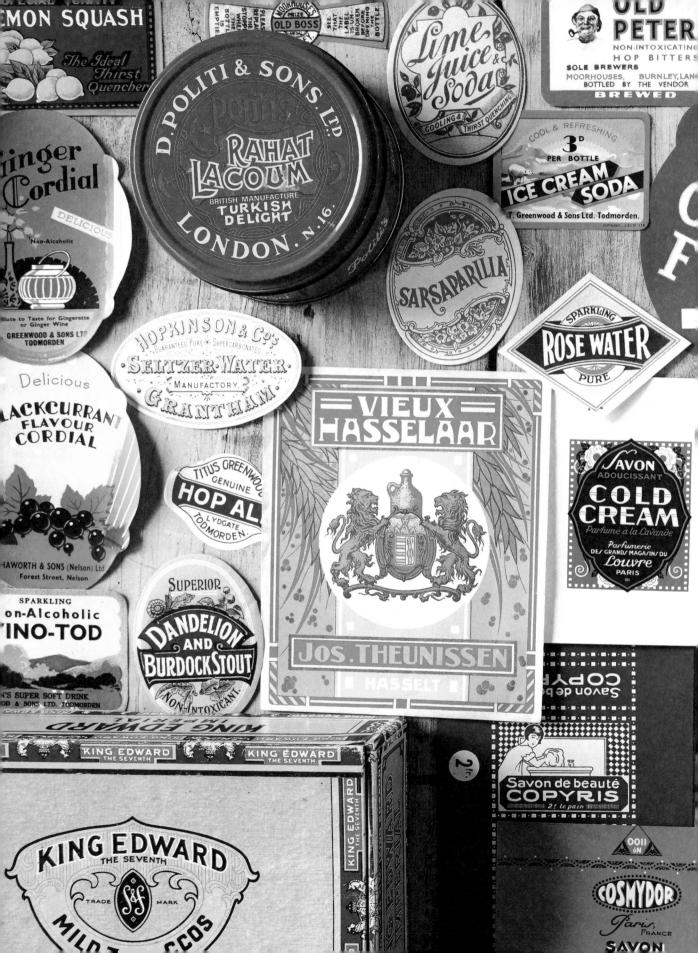

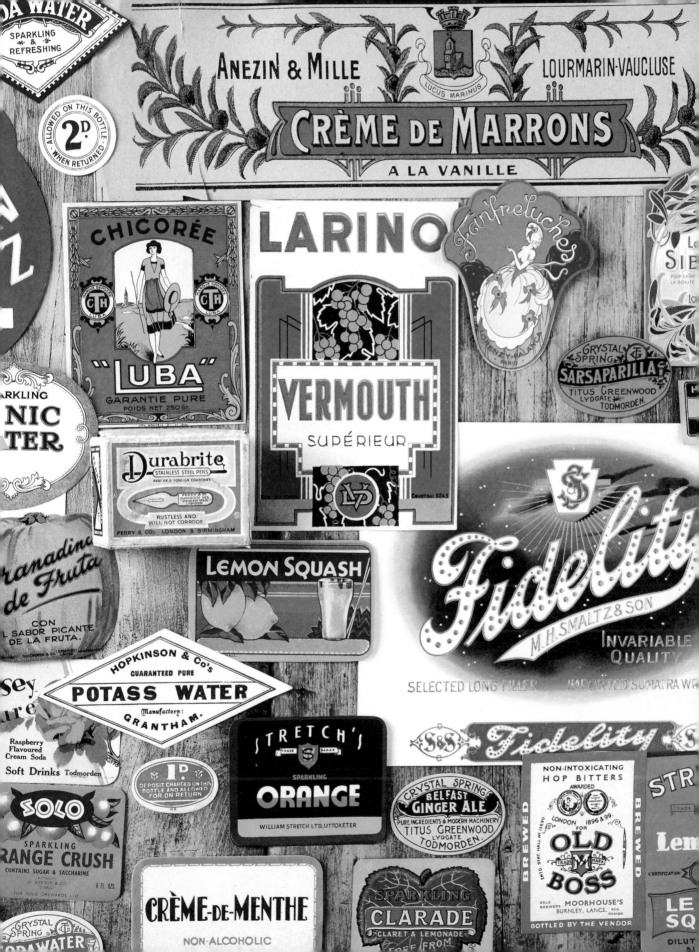

Hand Lettering

Hand lettering is all about looking at type and creating your own lettering. You may want to directly copy a typeface that you like, or you may prefer to develop your own lettering, based on inspiration that you've found. There is so much type to be found all around us!

There are a number of different styles of letters including serif, sans serif, script, block letters and decorative letterforms.

To create your own lettering, it's a good idea to start by looking for some inspiration. I often find inspiration in vintage printed ephemera and shop signage.

Think about what you want to hand letter, and think about what kind of feeling you want to create. Do you want to write one word that is a show-stopping ornate piece of lettering? Or hand letter a quote and pick out certain words? Think about the meaning of the words and what you want to express. You don't have to be too obvious – sometimes lettering works well because of a contrast; for example, saying one thing, but in a style that implies something else. The important thing is to think about what you want to say and how.

Once you have an idea then you can look through your choice of inspiration to help you flesh out your ideas. You need to think about the hierarchy of what you're saying (which are the most important parts) and how you want to express this. Pick out elements you like from your inspiration and draw and develop your ideas from here.

It's really good to practise your drawing skills by trying lots of different styles of lettering. This is a great starting point for a sketchbook. Pick out and stick in images that you like and draw them. I prefer to use a Pigma fineliner for this. This will help you to get a feel for how letters are created, and enable you to develop your own ideas.

Try drawing serif letters, making sure your serifs are consistent.

The serif is the line at the end of a stroke.

Look at drawing script fonts as well; you can make more of a feature of the ends of the strokes.

Look at sans serif letters. Sans serif literally means 'without serif'.

You can try drawing more solid sans-serif letters, and create borders to your letters to help make them stand out.

Script styles are easy once you have an understanding of calligraphy, as you know where to thicken the strokes in the correct places.

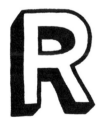

A drop shadow is used to give a 3D appearance to letterforms. In order to create this effect, you need to work out where your light source would be in order to have the 'shadow' falling in the correct place. Decide where your light source is and **stick with it!** Do not move it around or the effect won't work.

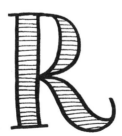

Instead of a solid filled shape, this letter has a decorative fill. Think of vintage fairground and circus lettering, or Victorian display fonts.

A swash – the letterform has been extended at the end of a stroke, as you would in calligraphy.

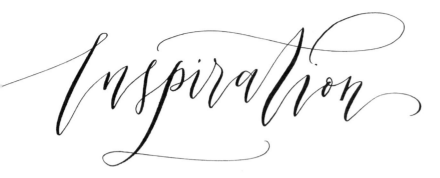

I love type and lettering. I am constantly taking photos of type when I'm out and about and I collect all sorts of printed ephemera. There's lots of lovely stuff on Pinterest, but it's always good to look a bit further afield to keep your work fresh – look for examples that not everyone has seen already!

Junk shops, your own attic, vintage books, old shop fronts – there is inspiration to be found everywhere. Vintage packaging can be useful for ideas on layout and composition too.

Lots of Victorian fonts are great as they are super ornate, with lots of ways you can add interest to your type. Find elements you like and try drawing them.

Once you've found some examples of type that you love, then it's time to start drawing. Start by sketching out the letterforms lightly to get the proportions and size right, and then you can work over them in greater detail.

On the following pages, I've put together a selection of pieces of packaging from my collection, and picked out the elements that I like and might use as a starting point for my own lettering. When you find something you like, try to dissect the elements you find appealing and think about different ways in which you might be able to work with them.

I've picked out this R because I like the
decorative finishes at the top and bottom
of the letterform. It really stands out
because of the striped fill and drop shadow,
which make it even more striking.

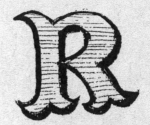

I love the colour palette in this label, in particular
the red and gold lettering, and also the striped
borders. I like the top lettering, which is really solid
and round, and then the contrast with the more
condensed lettering of 'Vermouth' below.

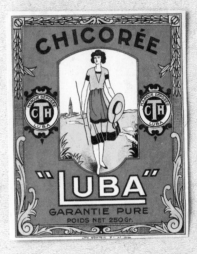

Again the colour usage here appeals to me
– the red, black and yellow. I love the way
the L of Luba is extended along the bottom
underneath the UBA. The decorative borders
here are pretty awesome too.

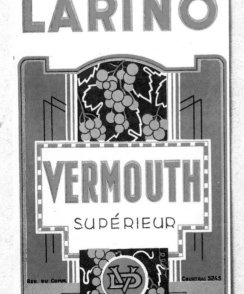

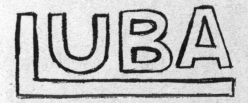

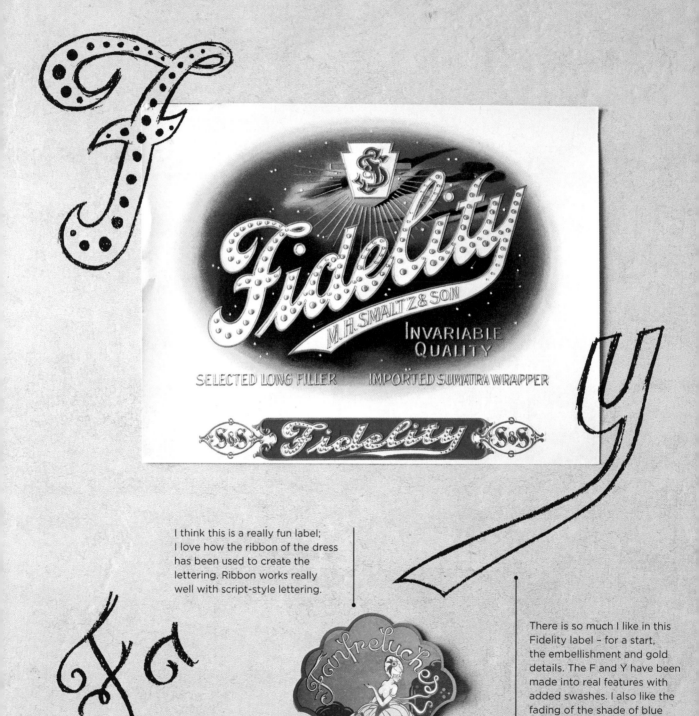

I think this is a really fun label; I love how the ribbon of the dress has been used to create the lettering. Ribbon works really well with script-style lettering.

There is so much I like in this Fidelity label – for a start, the embellishment and gold details. The F and Y have been made into real features with added swashes. I also like the fading of the shade of blue behind the text.

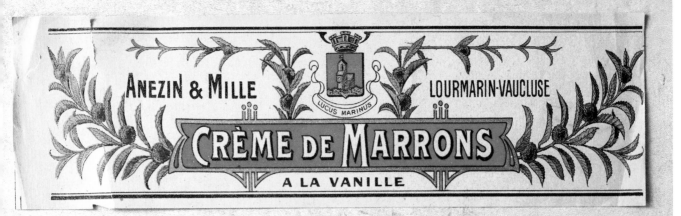

SAVON really stands out for me on this label. I love the A with the inverted triangle helping to create the counter-space.

I love the gold and black floral decorations here. It's interesting how they are displayed in a fluid curve but also in an angular form. The emphasized C and M and drop shadow help the key lettering to stand out.

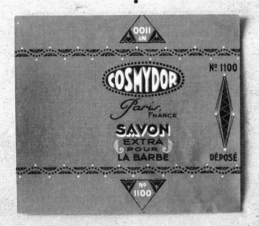

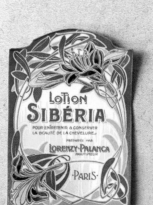

The P of Paris on this label really stood out to me; I love the style of it.

The ornate art nouveau border on this label really drew my eye.

PLANNING A PROJECT

If you look at the examples of vintage packaging you'll see that they will have a mixture of font styles. Key information will be bolder and more dramatic, with less important information in simpler styles. When planning a piece, think carefully about your copy: what's going to stand out? What is the most important thing you want to convey? What kind of tone do you want to set? Is it playful? Formal? Pretty? Feminine?

Think about the end use – what do you want to use the lettering for? Is it for a blackboard for a wedding? For your own packaging? Homemade labels? This is where it's great to think about hierarchy again. What structure are you thinking about. What do you want to say? What's the key information to convey?

On the facing page, I've taken a simple phrase and created a hand-lettered piece, using different elements I found in my collection of labels. I always start with pencil sketches. Using your inspiration pieces, sketch out the key elements that you like, then roughly work out your composition.

Start to work into it. Once you've established how the layout is going to look you can draw out the copy and begin to work on the line length and decorative text elements. Be aware of the space that the shapes and letters you create leave behind, and look at the piece as a whole, so it's balanced. Make sure it doesn't look as if all your detail is on one side, with gaping holes on the other. Think about using banners and shapes to re-inforce the lettering you are using, and look at other devices used on your source material. Suns, rays and fans are all pretty commonplace as backgrounds, as are ribbons and banners, often combined with a range of border designs and panels.

tip

LAYOUT / PAPER

When working on hand lettering, layout paper is a really handy tool. You can use it to copy over what you've done, and rework areas that you're not happy with. Just lay it over your artwork and redraw, editing and changing anything you are unhappy with.

I've combined the border from the vermouth label (page 87) with different lettering styles.

I really like the shape of the lettering in the water packaging on page 87, so I've used it as inspiration here.

What kind of feeling do you want to create with your lettering? I wanted to make 'happy' stand out but not in too formal a way. I created a script style of lettering, and added a drop shadow combined with a decorative fill.

I didn't want this word to detract too much from the above so I've gone for a more simple, less decorative style of lettering, although I've not entirely decided how I feel about this. It's all about trial and error.

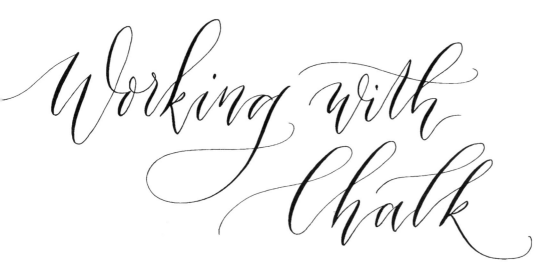

Working with Chalk

Hand lettering in chalk is really useful for creating dramatic work, whether it's for a wall in your home, a backdrop for your wedding or signage for your store. There are lots of ways you can use it to great effect. The added bonus is that if you want to change it all you can just rub it down and start afresh!

TOOLS YOU WILL NEED

- Make-up pencil sharpener (with a large opening)
- Craft knife or scalpel
- Chalk pencils
- Board rubber
- Cloths
- Cotton buds
- Pot of water
- Ruler
- Metre rule
- Chalk pens (optional)

Did you know that you can sharpen chalk? You can do it with a craft knife or scalpel, but by far the easiest way is to use a make-up pencil sharpener, as these have a larger aperture than a standard pencil sharpener that will fit a stick of chalk. I particularly like ones that have a container underneath that gathers all the chalk dust. You can use this in turn to prep your chalkboard surface! Using a sharpener is a great way to get a really fine point to your chalk.

If you want to create something more lasting, you can use chalk pens, rather than traditional chalk. Plan your work first using chalk, though, as you will be able to rub it out and correct mistakes more easily. Bear in mind that chalk pens will give a more flat, stark finish. Chalk pens (and white acrylic markers) are great for lettering on other coloured surfaces such as glass.

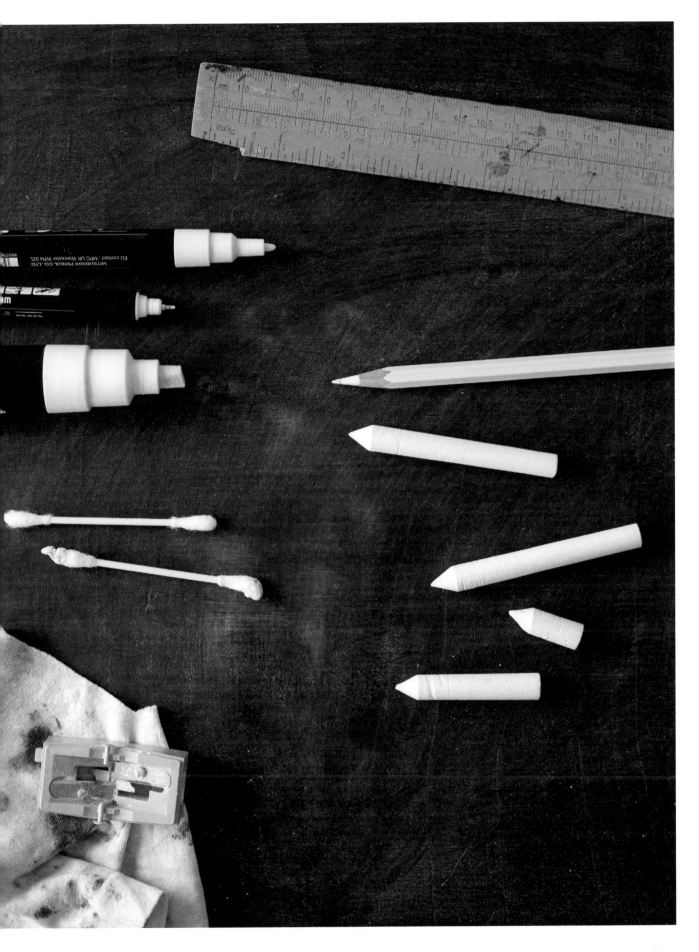

MAKING A CHALKBOARD

There are two ways you can do this. You can either buy blackboard paint, which is readily available but only in, well, black. Or you can make your own version using the following recipe, which will allow you to use your own custom colour as a backdrop.

CHALKBOARD PAINT RECIPE

You can create your own blackboard paint in any shade using household emulsion (latex) paint and unsanded tile grout (which is smoother than sanded grout). The addition of the grout to the paint creates the chalky surface to work with.

- Board/piece of wood
- Sandpaper (optional)
- Emulsion (latex) paint in a colour of your choice
- Unsanded tile grout
- Plastic bowl and something to stir with
- Small paintbrush or roller

STEP 1

Cut your piece of wood to the desired size and shape. Lightly sand the surface to get rid of any imperfections so that you have a nice smooth surface.

STEP 2

Mix the grout into the paint using a ratio of 1:10. So, for example, if you were using tablespoons to measure out your paint, you would add one tablespoon of grout to ten tablespoons of paint. Increase the quantities as needed until you have enough to cover your surface.

Carefully apply at least two coats of your blackboard paint to your board with a brush or small roller. Paint in nice even strokes and keep a good flat surface as it will be harder to write on if you have lumps and bumps! If your first coat has any unwanted lumps you can get rid of these with sandpaper before painting the second coat.

BE PREPARED

Always buy more chalk than you think you'll need, as it invariably breaks at a crucial moment. If you're sharpening it, you'll get through a fair amount!

PREPARING YOUR SURFACE

Your wall or board is beautifully painted with blackboard paint, and you are about to start writing on it. Hold your horses! The first thing to do is prep it by lightly scuffing the entire surface with chalk. The easiest way to do this is by roughly going over the surface with the side of a piece of chalk so you get a very light covering of chalk. Otherwise, you can use a cloth dipped in chalk dust, then use your board rubber to rub it all off. This will leave a chalky residue so that your surface is no longer a really flat black (or colour), but is a more mottled dusted surface, to give a more authentic feel to your work and stop pronounced ghosting the first time you use it.

PRACTISING YOUR STROKES

It's always important to get a feel for your tools. Test the chalk, with different pressures, straight from the pack and then also sharpened with a (make-up) sharpener. This helps to give you a good point and a fine line, although for finer point lines a chalk pencil will give you the edge. Practise your techniques on a spare piece of blackboard or black paper.

EXPERIMENT WITH LETTERING STYLES

This is another chance to use some of the great source material you have gathered while looking at your hand lettering. Practise trying out some of these letterforms, and see how you can play with these using the medium of chalk. Chalk offers some great effects: you can get different levels of light and dark by shading with chalk, or by smudging it, and there are a few different options for tones. The great thing about chalk is that you can create other lines by removing chalk, using positive and negative areas to create your lettering.

ADDING DIMENSIONS

Work with 2D and 3D letters to add interest to your lettering. You can create 3D letters in a variety of ways by adding a drop shadow in a solid colour, or lined fill, or reinforce the shapes with an echoed line.

PLAN OUT YOUR PIECE

Always plan out what you're going to do, so you can work out the spacing. Plan your chalkboard using pencil on paper to begin, so you can think about your layout. You can then measure this and scale it up for your finished piece. Start by measuring your design and working out how many lines of text you need, and the relevant line lengths. To centre things, work out the middle point of your line of text by counting all the characters AND spaces and then work out which is the middle.

For example, look at this sentence: **'All of our hopes and dreams.'**

The 'o' of 'hopes' would be your midpoint. If you always line up the middle of your line to the piece then it will be perfectly balanced. The beauty of working with chalk is that you can sketch out your work on your final piece, and very easily get rid of any sketched lines using a damp cloth, or indeed any mistakes!

THINGS TO BEAR IN MIND

Make sure your piece is well balanced and composed, that it's not heavier on one side than the other, and that the negative space works as well as the lettering. Think about the piece as a whole, not just as letterforms. The space around the letters is just as important! It's great to mix lettering styles, but bear in mind that, sometimes, less is more. Having eleven different lettering styles may make your finished piece look very disjointed, so a good guide is to keep to around three styles. Always think in terms of balancing contrasting styles: pair an intricate, 3D lettering style with a simple serif font, or pair an elaborate script style with a simple sans serif. Play with size and scale, pick out elements and make features of them, and fit other lettering around this. Try adding borders, as these can work to great effect, as do banners to which you can add interesting shading.

TO CREATE A SIMPLE CHALKBOARD

To create a simple chalkboard, look at some existing fonts that you like. Try drawing these, playing with mixing the styles between script, serifs and sans serifs. When you feel more comfortable with drawing lettering, you can start to experiment more with creating your own hand lettering.

Look at different lettering styles, and the message/tone of the piece you want to create. Different styles convey different messages. Script styles like 4 can be elegant, formal, or romantic. Versions 5, 6 and 7 are simple and bold. 7 is bold but in quite a fun way. 11 is fun and childlike. Try writing your chosen words in different styles, and think about what will work well in your design.

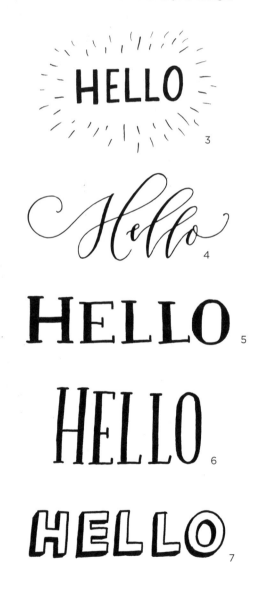

HELLO SUNSHINE 1

Write out your chosen word or quote. If you are using more than one word, think about the hierarchy. Which words are more important or would you like to highlight? Which are less so? Words such as 'and', 'the' and 'it', will probably not need to stand out as much as others.

HELLO SUNSHINE 2

I think 'sunshine' is the most significant word here, so have reduced the size of 'hello'. I made the S of 'sunshine' larger, and 'hello' fits nicely into the space next to it. Positioning the main word at an angle diagonally across the piece might give even more emphasis.

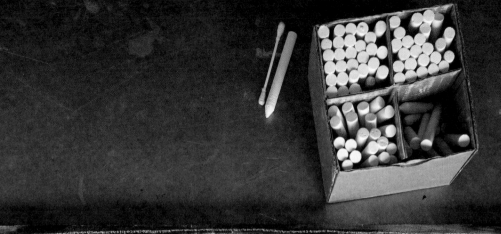

HELLO. 8

HELLO. 9

 10

HELLO. 11

 12

HELLO
SUNSHINE 13

HELLO
SUNSHINE 14

13 and 14. Start thinking about composition. Here I quite like the idea of writing on an angle, although I prefer 14, with 'hello' on a horizontal line and 'sunshine' at an angle.

SUNSHINE 15

15. Experiment with angles. Here I started with a serif font, and then realized that I didn't like it for this.

Sunshine 16

Sunshine 17

Sunshine 18

16–18. Look at script lettering to see how this works. Start with a simple script word, and analyze how it can be developed with flourishes or swashes.

HELLO *Sunshine* 19

19. Finally, work on combining the two for the finished piece.

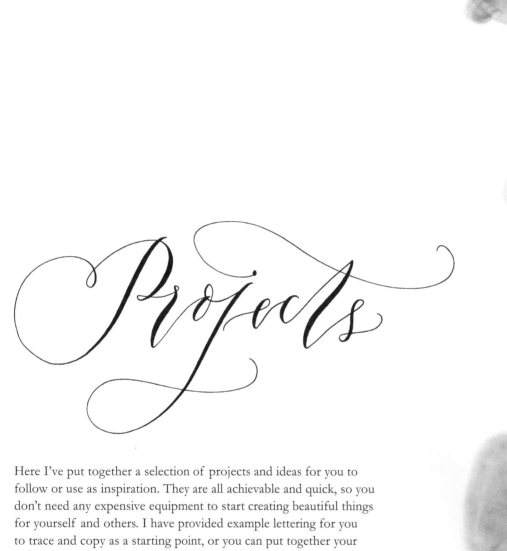

Projects

Here I've put together a selection of projects and ideas for you to follow or use as inspiration. They are all achievable and quick, so you don't need any expensive equipment to start creating beautiful things for yourself and others. I have provided example lettering for you to trace and copy as a starting point, or you can put together your own words and phrases. Now you've started on your hand lettering and calligraphy journey, the only limit is your imagination!

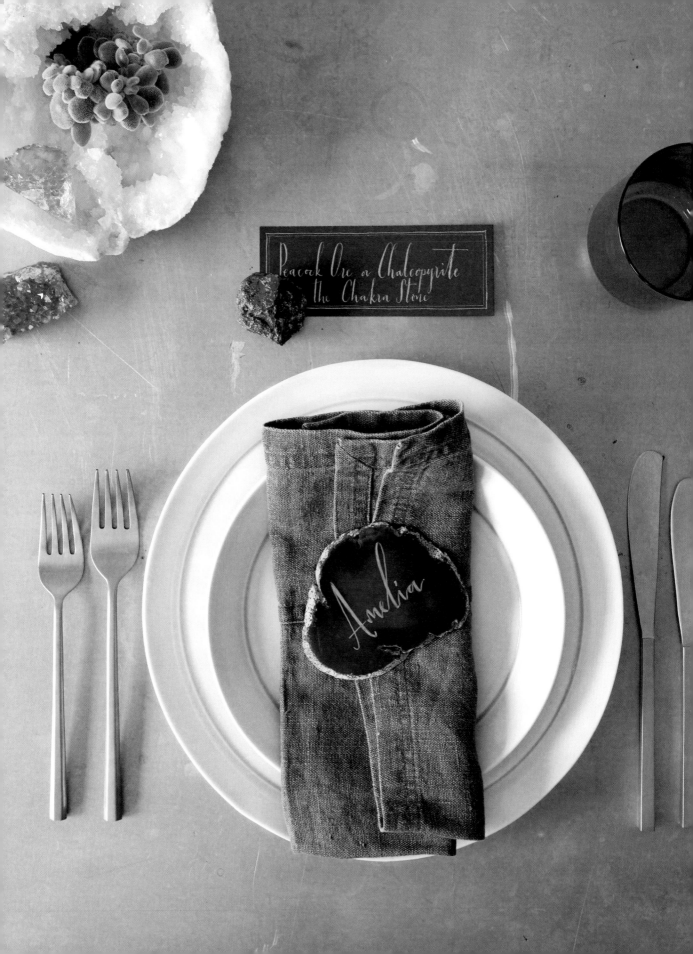

Peacock Ore a Chalcopyrite
the Chakra Stone

Amelia

MODERN CRYSTAL WEDDING

Crystals are amazing things, and this style of wedding table is all about embracing the stunning natural colours in the stones. Whether you go for stormy blues or moody malachites, this scheme works really well with pops of gold or copper to provide a contrast to the rich gem and mineral colours.

CHOOSING COLOURS

Crystals and minerals – with raw edges or sliced and polished – are a great way of adding a difference to a wedding and come in an array of stunning colours and shades. There are pale stones with whites, clear crystals, soft pale pinks and purples, wonderful bold cobalts, and deep amethysts and malachite. Choose stones that complement your wedding colours: ethereal pale colours and textures in whites and soft pastels, or bold and dramatic midnight blues, like I've chosen here.

INKY ACCENTS

Whichever colour scheme you go for, choose papers in complementary shades, and use a contrasting accent colour such as the gold here. Match your paper to your chosen crystals and use the colour across the stationery to bring the scheme together. Darker stones work really well with accents of gold, which I've used here with the cutlery, the ink on the blue paper for the favour label, the menu (page 107) and the blue of the stone. Finetec palettes (see page 54) are great here as they offer a really good variety of shades of gold.

FAVOURS

You could choose crystals for their healing properties as I've done here using actual stones for wedding favours, paired with a handwritten label. Glassy angular sugar sweets could also be added – think about using things that will nicely echo the crystal structures.

THE LETTERING

This table is very modern, so I didn't want to use a lettering style that was too flourished or romantic. A more spidery, angular style of script works better here. Use a style of lettering that echoes the sentiment you're trying to create. See page 106 for a few examples to try for yourself.

Let's Party!

Menu

to start

to follow

to finish

to drink

Menu
to start
Textures of beetroot with
goats curd & seeds
to follow
Rack of lamb with celeriac
dauphinoise & root vegetables
to finish
Nougatine parfait & vanilla
poached rhubarb

Sophie Lowe
&
Adam Church

invite you to join in the
celebration of their marriage
Saturday the first of May
at two o'clock in the afternoon
Castle Giacomo
Tuscany

TUSCAN WEDDING

The charm of a romantic Tuscan countryside wedding lies in the details. Here simplicity is key, so let the lettering shine out amid a few well-chosen rustic touches.

WATERCOLOUR DETAILS

This is a classic wedding style. Think rustic wooden trestle tables under a Tuscan (or Provençal) sun, olive leaves entwined around candles, simple but pretty and rather informal. To echo this theme I've created stationery with flowing, pretty calligraphy combined with watercolour illustrations on a textured paper. I've torn the edges to emphasize the rustic feeling, or you could use handmade or Khadi paper. Green inks are great for this scheme, but you could also opt for pale greys or purples. Whichever colour you go for, use the same ink throughout to create a cohesive look. The invitation opposite is a simple, open design with leaf motifs encircling only the couple's names – see page 110 for a more contained version.

PLAYING WITH PAPERS

White or natural linens work well for this scheme, as does khadi and watercolour paper, as well as brown and craft paper. Think raw, rough edges and simple, neutral colours working with an accent colour. Experiment with natural paper stocks. I've created the menu for this wedding out of a translucent paper wrapped around the bread, and tied with rustic string (see page 111).

TAG TEAM

Stick with the rustic handmade feel and make your own favours. A small bottle of herb-infused olive oil makes a great favour, and a skinny paper tag won't dwarf the bottle. Make your own lavender vinegar, or infuse your own spirits. Just pop in a bottle and use the same torn-edged paper to create your label. Hole punch it to thread, using the same rustic string as seen on the menus.

Mr & Mrs
Alexander Campbell
cordially invite you to celebrate
the marriage of their daughter

Isabella Grace

to

Benjamin Hepworth

at
the church of St. Michael, Aynho on
Saturday, 16th July 2016 at
3 o'clock and afterwards at
Aynhoe Park, Aynhoe
OX17 3BQ

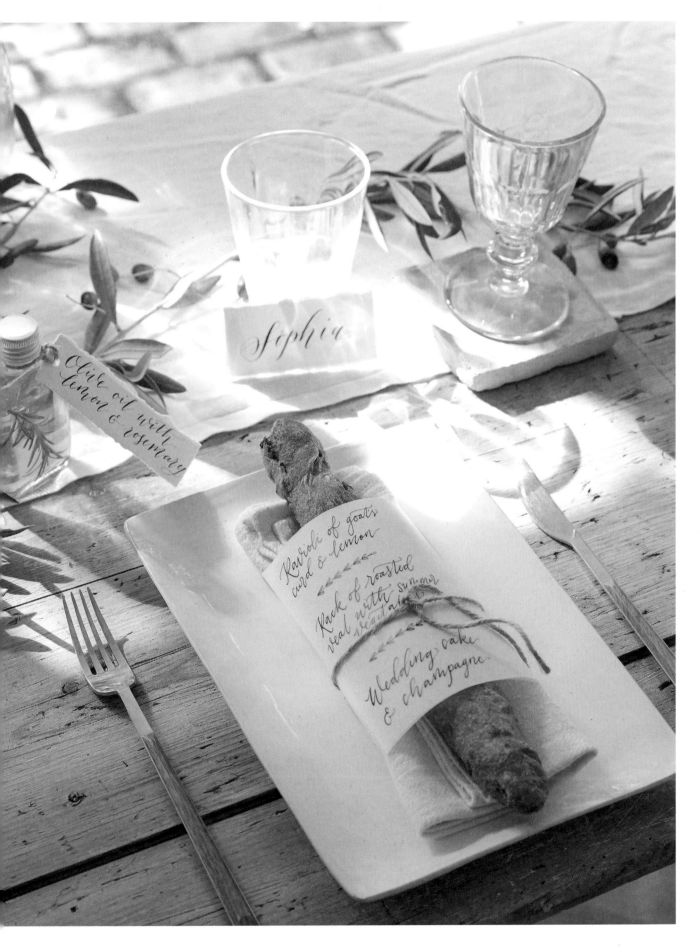

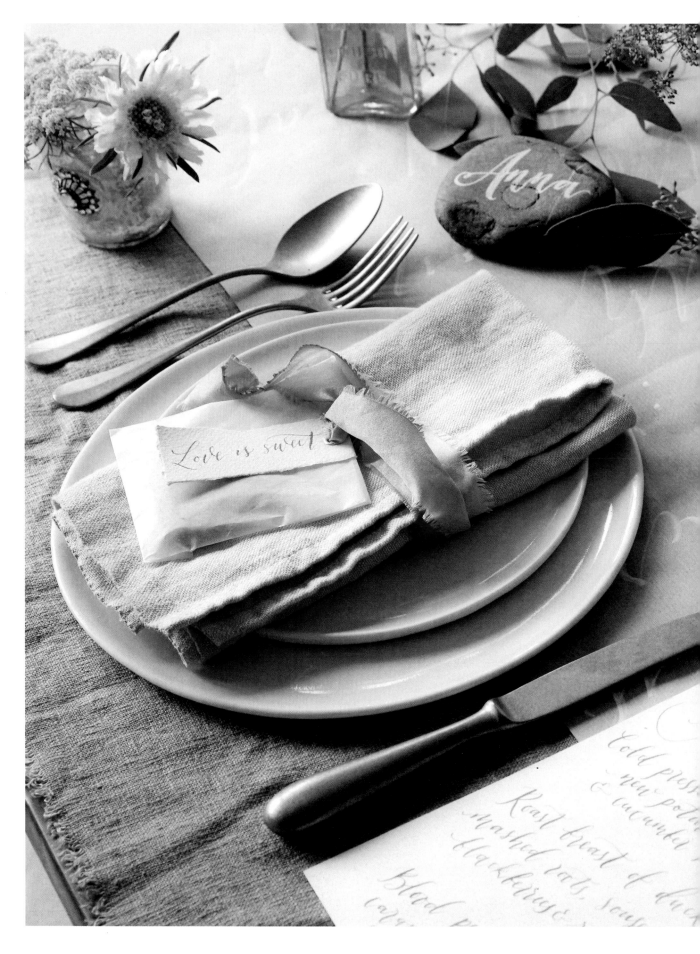

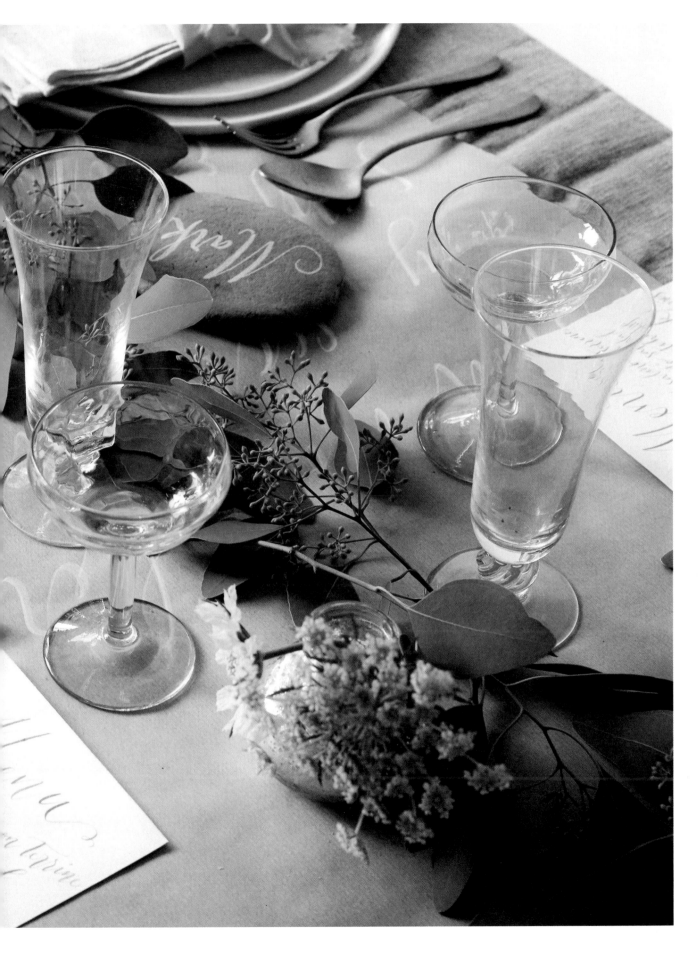

ROMANTIC WEDDING

Everything in this scheme is natural, pretty and pared back. This works to create a simple yet subtly romantic design with a feature table runner.

SETTING THE SCENE

This wedding table is centred around soft romantic hues teamed with natural materials, hand-dyed silk ribbon with frayed edges, with a brown paper runner of interwoven greenery and white florals. Pebbles serve as place names, with lettering in white, using acrylic marker. White frosted sea glass would work really well too.

A SOFT TOUCH

All the calligraphy has been created in white or pale dove grey, to soften the tone of the table. I've used a loose and more flourished style to echo the romantic feeling, and worked with custom-mixed gouache ink. Hand-frayed silk has been dip-dyed to complement the scheme, used to finish the place setting and tie the homemade biscuit favours. The favours, presented in glassine bags, are a sweet little touch. The misty white of the bags works well with the romantic feel, and gold eyelets punched into the bags seal them and add a sophisticated finish. You could also make placemats out of fabric or paper with some extra calligraphy touches. I have provided a few examples on the facing page.

TABLE RUNNER

A simple brown paper table runner sits perfectly with grey table linen, and is a great way to add a really special personal touch. I've written out a favourite quote from *The Little Prince* about love (see page 116), but choose a quote that means something to you. To create a table runner like this, you'll need to know the dimensions of your table and what is going to be sitting on top of it. There is no point spending hours writing out a beautiful quote if it will be buried under a floral centrepiece. So be aware of where things are going to be on the table. You can always repeat the quote, so you have a backdrop of lettering along the table but with the quote also clearly written out at each end. Wherever you are going to write, make sure you lightly draw pencil guidelines first. Text on this table runner would also look effective written on an angle or horizontal. You could also write on fabric to create a linen table runner, although I would suggest something lightweight and possibly gauzy. Make a matching table plan using the same brown paper.

Eat drink & be married

Love is sweet

Find your seat

Table 1234567890

It is only with the heart that one can see rightly what is essential is invisible to the human eye

Antoine de Saint-Exupery
The Little Prince

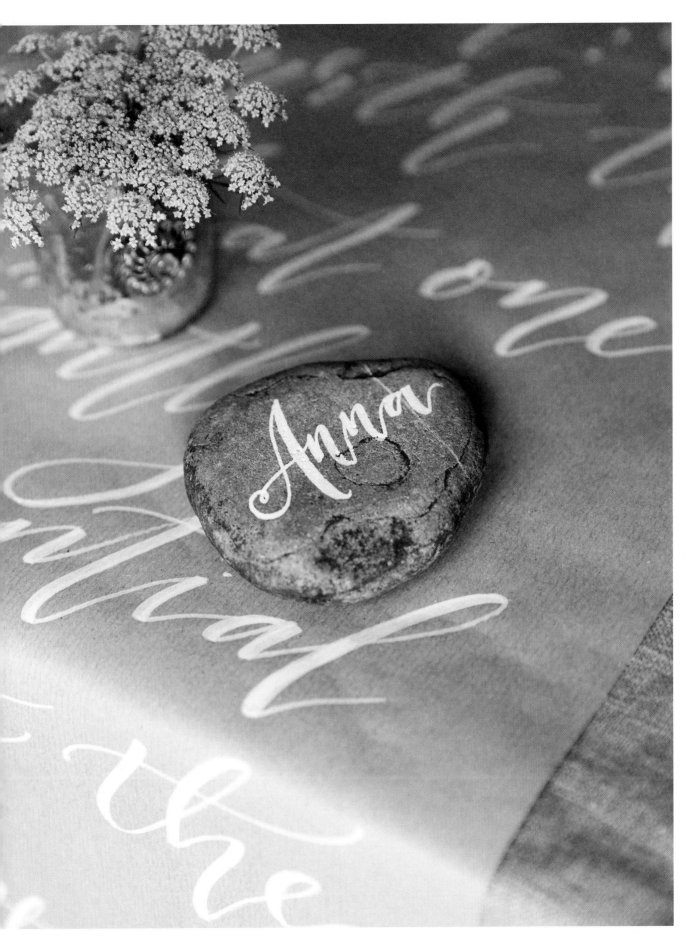

Mr & Mrs
Alexander Campbell
cordially invite you to celebrate
the marriage of their

Isabella

Benjamin

the church of S
Satu
at 3 o'cl

Menu

Pea pannacotta, Serrano ham, scorched
lardo & garden salad

———

Roast Guinea Fowl breast, baked
celeriac, oats & braised celery

———

Baked saffron custard, gooseberry
& ginger beer sorbet & poppy seed tuile

———

BOTANICAL WEDDING

This wedding is another rather modern one, so I've paired a more elongated and unbalanced spidery style here with hand-drawn illustrations to soften the tone.

GO GREEN

This style is all about lush greenery, given a modern feel with white marble and copper. Here I've used ferns, but this modern green wedding look would work just as well with concrete and succulents. It is a simple look, with emphasis on the natural shapes of the foliage. I've used illustrative elements on the invitation, which sit nicely with the spiky lettering. I've chosen a green card with white ink for my menu, for a softer look that contrasts with the invitation. For a variation on this style you could use more tropical foliage, teamed with a bright accent colour such as a vibrant coral.

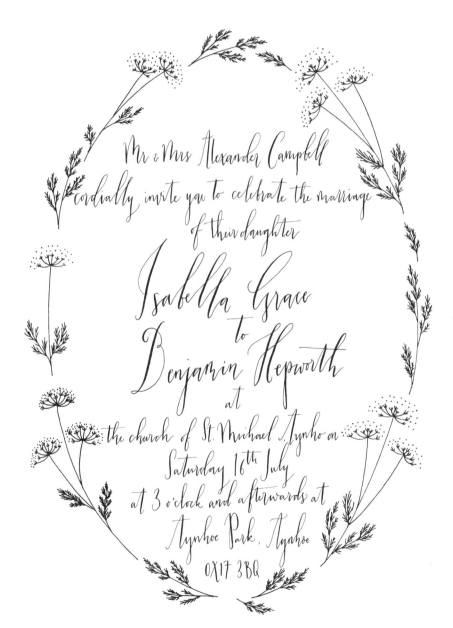

PLACE NAMES

Bold green foliage creates texture and pairs beautifully with marble and rough-finished ceramics, with copper metallic accents in the cutlery. Writing on an actual leaf is a great way of creating a place name that fits really well into this table setting. If you want to use the same plant leaf for all the place settings, look for one that is going to fit your longest guest name! To write on leaves, pick a nib that's not too sharp or you'll find you keep puncturing the surface. If you find it too tricky then acrylic marker will work; just fatten your downstrokes.

SEED PACKETS

The favours for this setting are individual seed packets, so you can 'let love grow'. I've written in white ink on small brown envelopes, and then filled them with wild flower seeds. Combining green papers here with white lettering would also work well, or try using white with metallic copper.

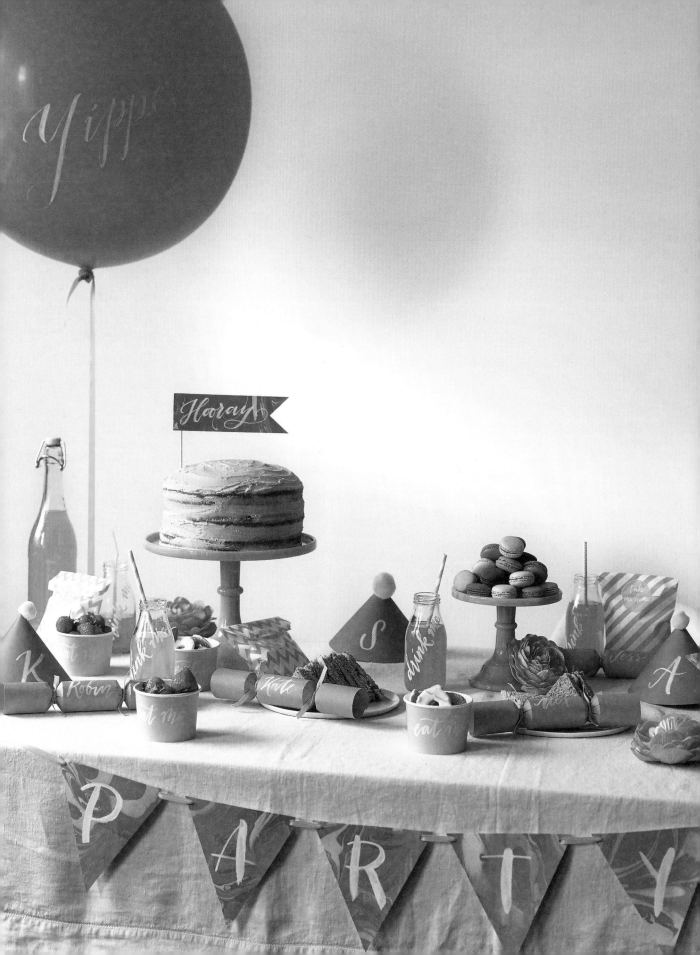

THE PERFECT PARTY

There are lots of ways to customize a party using your calligraphy and lettering skills. Here are a few fun ideas to get you started, but don't be afraid to experiment... There are so many choices of partyware available, and you can create an awesome table in pretty much any colour you like, so why not be adventurous?

BALLOON

This is a great and super-simple way to make a statement! You'll need a steady hand and a chalk pen or acrylic paint marker (anything water-based will not adhere very well on this surface). Once you've inflated your balloon, find a lovely helper to hold it steady for you, so that you can write across the surface. It's a good idea to plan and try out what you're going to write first on paper, and always test the pen on paper for a couple of strokes before you start on the surface of the balloon, to get the ink flowing! Write your chosen statement, and then go back and add weight to where the thick downstrokes should appear.

CAKE TOPPER

Choose a thick paper or card stock and cut out your chosen topper shape. You can then use any of your lettering skills to decorate it... let your creativity run free! Fold around a cocktail stick and secure with a small dab of glue.

BUNTING BANNER

There are so many awesome things you can do with paper, and marbling is a simple but very effective technique. You can buy marbled paper or get a kit and try it yourself. Once you have your marbled paper, make a cardboard template the shape you'd like your bunting flags to be, and then draw around it and cut out enough flags to make your banner. Brush or hand lettering is great for making a bold statement using a single letter on each hanging shape. Use a hole punch to make holes in each side and thread with a contrasting colour ribbon.

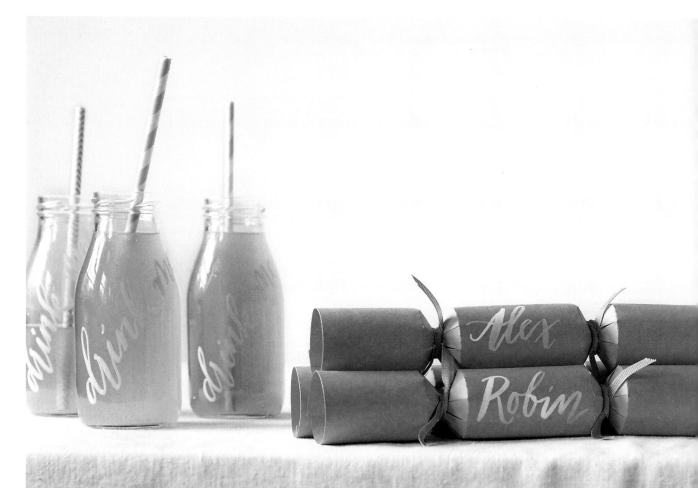

DRINK ME BOTTLES

I love these vintage milk bottles and they look great on a party table. This project looks particularly effective if your drinks are going to be dark or coloured. You can always use a bit of masking tape as a guideline to help you to write in a straight line, although make sure you allow enough room for your lettering above the masking tape. This is a task for a chalk pen or acrylic paint marker. Write your lettering and then thicken the appropriate downstrokes afterwards to keep it looking authentic.

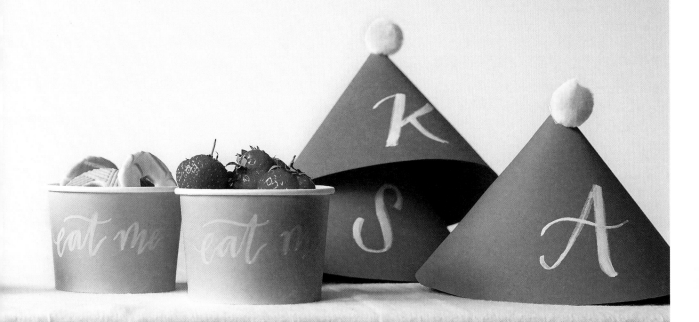

CRACKERS

You can find cracker blanks and kits at craft stores and online, which means you can have some really cool bespoke crackers for your parties. You can personalize these by writing on them before you make them up. Calligraphy will give a more sophisticated look, whereas bold brush or hand lettering is great for children's parties!

EAT ME CUPS

There are so many cool party supply stores selling these paper cups that you can use for ice cream/berries/popcorn or whatever takes your fancy. You can customize them easily with an acrylic paint marker, or an acrylic brush pen. They tend to have a shiny coating so you'll need an acrylic ink or similar to work properly, although a Sharpie pen will do the trick too. See page 126 for some labelling ideas.

PARTY HATS

These are really easy to make. Draw out a circle onto paper, and then cut out a section like a slice of pie, so you can curve it around to make your hat. Work where the middle on the opposite side to the join will be. This is the best place to write. You can use calligraphy, brush or hand lettering to personalize your party hat. You could even use a brush and glue to create your lettering and then liberally dowse it in glitter! Make up the hat, then punch holes in the side or use a stapler to attach ribbon or elastic so it will stay on.

Celebrate

Yippee

eat me drink me

PARTY BAGS

There are lots of fun things you can do with party bags. You can try glassine or paper bags, and there are so many cool colours and patterns to have fun with. You can buy great coloured stickers that you can use to seal your bags – this is another perfect place to add a little message or greeting using your new lettering skills. You can write using a Sharpie or marker pen, or use nib and ink – you'll just need to do a test first to check it'll adhere to the surface of the sticker. You can readily buy all sorts of coloured paper stickers – customize with a message of your choice. Use black or dark inks on pale colours, and white on darker shades for maximum contrast. Neon and metallic inks can really add a pop to your party!

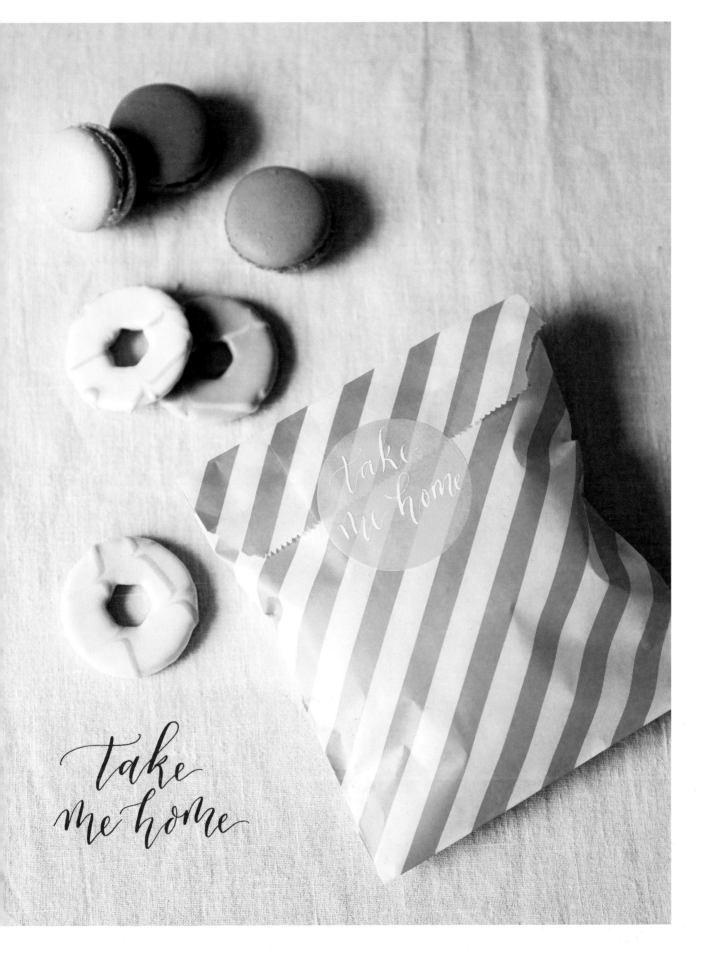

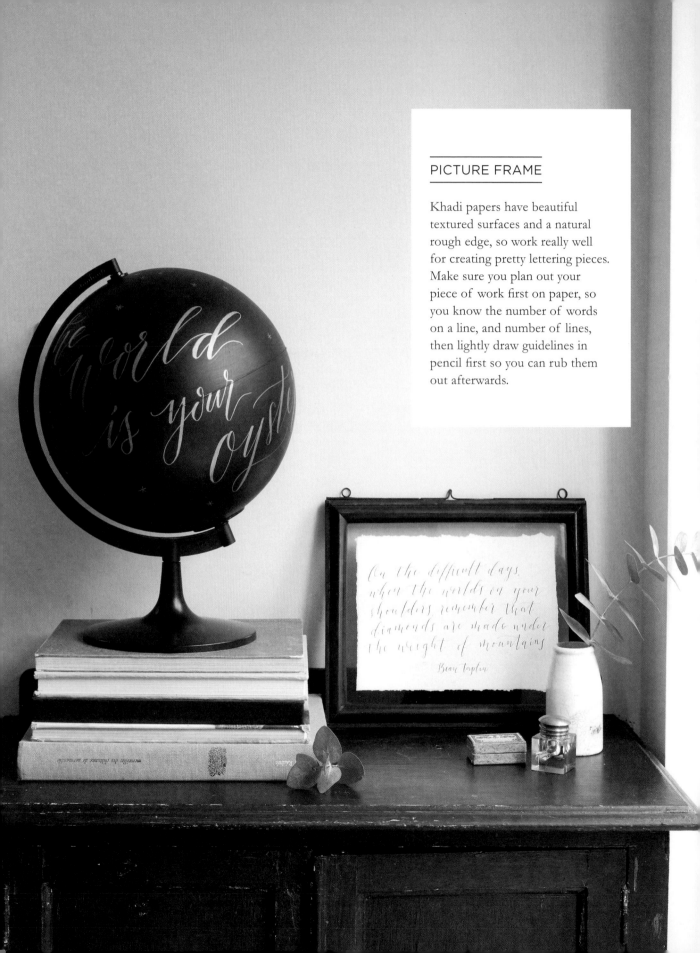

PICTURE FRAME

Khadi papers have beautiful
textured surfaces and a natural
rough edge, so work really well
for creating pretty lettering pieces.
Make sure you plan out your
piece of work first on paper, so
you know the number of words
on a line, and number of lines,
then lightly draw guidelines in
pencil first so you can rub them
out afterwards.

STYLE AT HOME

There are lots of opportunities to add style to your home using your new skills. Frame your favourite calligraphy quote or be more adventurous in adding lettering to your home – from styling up your pantry to painting a blackboard wall in your kitchen, let your imagination run free…

GLOBE

You can pick up new or vintage globes really easily. I painted this one with blackboard paint, it needed a few coats to give a really nice surface to work with, and you might need to give it a light sand first with some fine-ish sandpaper to give the paint a better surface to coat. You could write on it in chalk, but I created this lettering with a gold Sharpie pen. Plan out what you're going to write on paper first. Use chalk to lightly draw guidelines that you can easily get rid of afterwards. Use your pen, or brush and paint, to create fake calligraphy, making sure you remember to fatten all of your downstrokes.

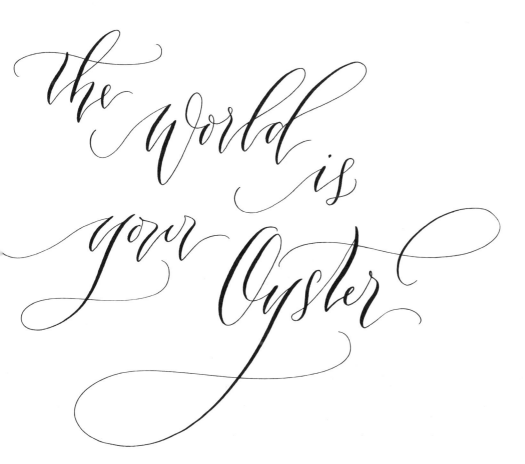

the world is your Oyster

A flower blossoms for its own joy

VASE

A quote written around this jar
using a black Sharpie pen works
really well, and it's such a simple
trick. Use masking tape around the
vase to give you a straight baseline
to work to. Add your descenders
once you've removed the tape.

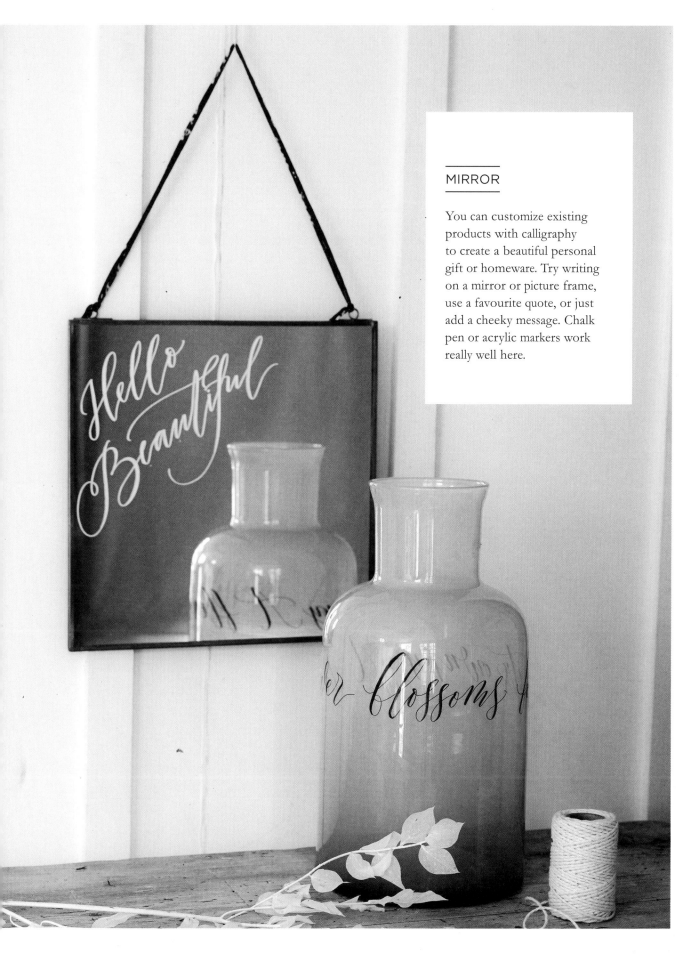

MIRROR

You can customize existing products with calligraphy to create a beautiful personal gift or homeware. Try writing on a mirror or picture frame, use a favourite quote, or just add a cheeky message. Chalk pen or acrylic markers work really well here.

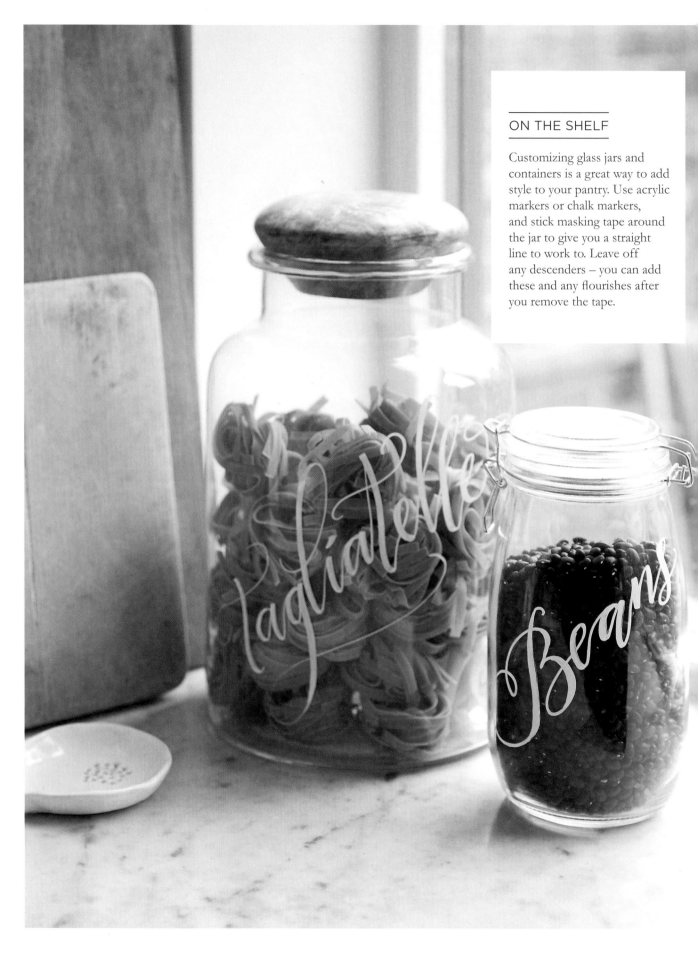

ON THE SHELF

Customizing glass jars and
containers is a great way to add
style to your pantry. Use acrylic
markers or chalk markers,
and stick masking tape around
the jar to give you a straight
line to work to. Leave off
any descenders – you can add
these and any flourishes after
you remove the tape.

Tagliatelle

Flour

Arborio Rice

Sugar

Beans

Spaghetti

Pasta

Marmalade

Cake

Biscuits

Homemade Cookies

Strawberry Jam

from the Kitchen of

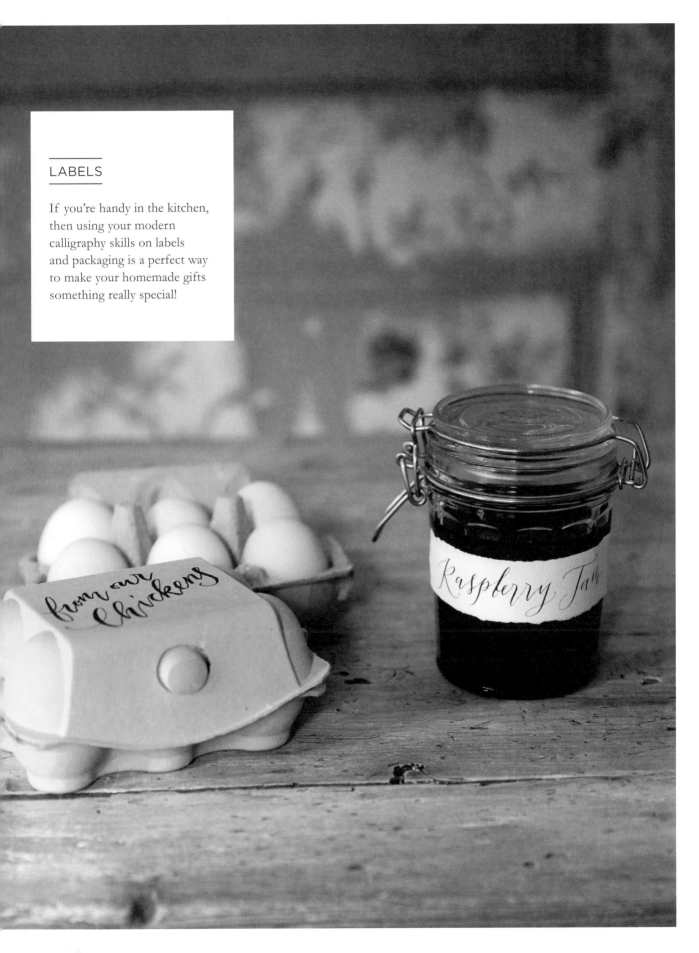

LABELS

If you're handy in the kitchen, then using your modern calligraphy skills on labels and packaging is a perfect way to make your homemade gifts something really special!

GIFT WRAPPING

An easy way to add your own style to celebrations and holidays is to make your own gift tags and wrapping paper. This is really easy to do, and adds a lovely personal touch.

WRAPPING PAPER

This is a brilliant way to use your calligraphy and brush lettering skills to great effect. Buy some plain coloured paper or brown parcel paper, use a ruler to lightly draw some guidelines, and you are good to go! I'd recommend using a brush and ink, or acrylic marker, which is easier when working on a large scale. Any paper over 90gsm is going to be hard to wrap with, so don't choose anything too thick. I'd always recommend working with contrasting shades. Light inks will stand out well on dark colours, and dark colours on light papers. If you're working with a light ink on a dark paper, you will need a good opaque ink or paint.

Hip Hip Hooray

Merry Christmas

with Love

with love

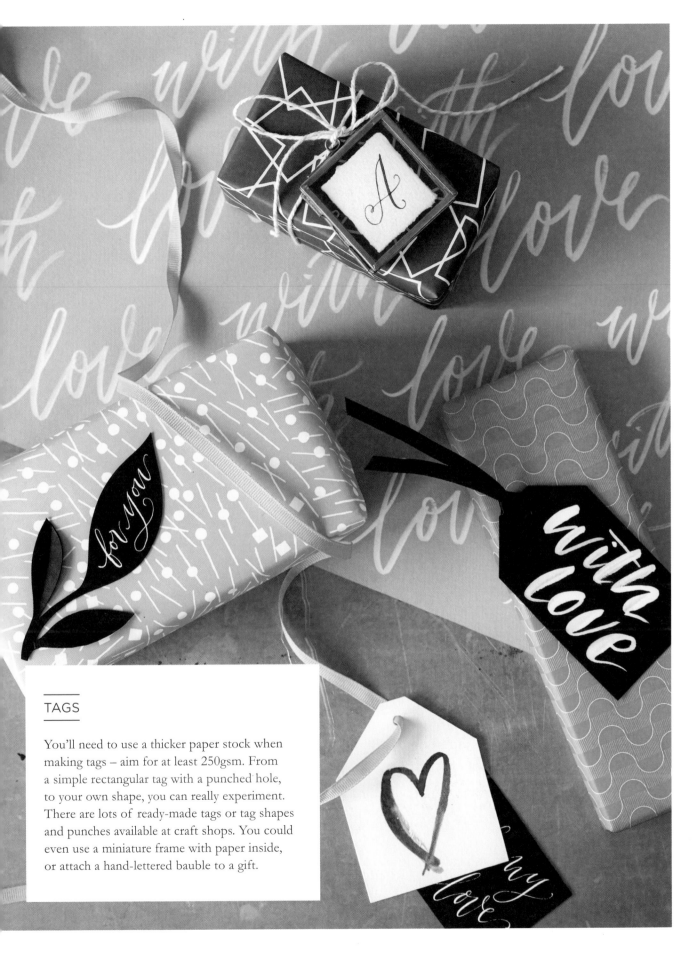

TAGS

You'll need to use a thicker paper stock when making tags – aim for at least 250gsm. From a simple rectangular tag with a punched hole, to your own shape, you can really experiment. There are lots of ready-made tags or tag shapes and punches available at craft shops. You could even use a miniature frame with paper inside, or attach a hand-lettered bauble to a gift.

STOCKISTS AND SUPPLIERS

When I started teaching modern calligraphy workshops back in 2013 it was hard to find some of the equipment and tools, so I spent a lot of time buying in and researching products from overseas. Now there are lots of supplies available online. I've put together a selection of my favourites in my online store. I have also created my own products, when I couldn't find exactly what I wanted! This is also where I post details of upcoming workshops, and sell my full range of stationery, including wedding and bespoke stationery.

www.imogenowen.com

LEARNING RESOURCES

Iampeth
www.iampeth.com

PAPERS

G F Smith
www.gfsmith.com

Paperchase
www.paperchase.co.uk

Papersource
www.papersource.com

Lawrence
www.lawrence.co.uk

TOOLS & SUPPLIES

Scribblers
www.scribblers.co.uk

Blots
www.blotspens.co.uk

John Neal Bookseller
www.johnnealbooks.com

Paper & Ink Arts
www.paperinkarts.com

Dickblick
www.dickblick.com

Jetpens
www.jetpens.com

Manuscript
www.calligraphy.co.uk

Cornelissen
www.cornelissen.com

BESPOKE PEN HOLDERS

Tom's Studio
www.tomsstudio.co.uk

Yoke Pen Company
www.yokepencompany.com

English Pencrafts
www.englishpencrafts.com

PARTY PAPER GOODS

Peach Blossom
www.peachblossom.co.uk

The Hooray Store
www.thehooraystore.co.uk

Pretty Little Party Shop
www.prettylittlepartyshop.co.uk

STYLISH HOMEWARES & FRAMES

Graham & Green
www.grahamandgreen.co.uk

Nkuku
www.nkuku.com

West Elm
www.westelm.co.uk

LETTERING ARTISTS

Jessica Hische
www.jessicahische.is

Martina Flor
www.martinaflor.com

Louise Fili
www.louisefili.com

Charles & Thorn
www.charlesandthorn.com

Seb Lester
www.seblester.com

Mary Kate McDevitt
www.marykatemcdevitt.com

LETTERING INSPIRATION

Vernacular Typography
www.vernaculartypography.com

My Fonts
www.myfonts.com

Found Type
www.foundtype.com

I Love Typography
www.ilovetypography.com

OTHER MODERN CALLIGRAPHERS

Megan Riera
www.meganrieralettering.com

Betsy Dunlap
www.betsydunlap.com

Molly Jacques
www.mollyjacquesillustration.com

Chiara Perano
www.lamplighterlondon.com

Plume Calligraphy
www.plumecalligraphy.com

The Left Handed Calligrapher
www.thelefthandedcalligrapher.com

Feast Calligraphy
www.feastcalligraphy.com

Bien Fait
www.bienfaitcalligraphy.com

SUGGESTED READING

Mastering Copperplate Calligraphy by Eleanor Winters

Louise Fili and Steven Heller each have a number of great books for hand lettering inspiration.

INDEX

ACKNOWLEDGMENTS

I'm incredibly lucky to have a super-supportive group of family and friends who've helped me with this book, and with my business when I had to take time out to work on it. Thank you to my mum and dad for always being supportive and nurturing my creativity. To all my friends and my brother who have believed in me and encouraged me when I needed help to take the leap of faith to get me started with my business, which led me here. I would like to thank the lovely team at Quadrille, who've been fantastic to work with, from Lisa for coming to meet me, attending my workshop and believing in me to start this project, to the ever-patient Amy, and the talents of Claire, Vanessa, Kim and Holly, who combined to make this book look really rather special. Thank you also to Tom's Studio for the stunning pen holders, Wrap and Ola for the beautiful wrapping papers and Theodora for her extra props. I'm also very grateful to the lovely Danielle for all of her assistance creating props. Also thank you to Lucy at Quill and Abigail Warner: upon seeing my Instagram, they both asked me instantly to teach a workshop, which was where this all started.

Publishing director: Sarah Lavelle
Commissioning editor: Lisa Pendreigh
Project editor: Amy Christian
Creative director: Helen Lewis
Designer: Vanessa Masci, Claire Rochford
Photographer: Kim Lightbody
Stylist: Holly Bruce
Production director: Vincent Smith
Production controller: Emily Noto

First published in 2017 by
Quadrille Publishing
Pentagon House,
52–54 Southwark Street,
London SE1 1UN
www.quadrille.co.uk
www.quadrille.com

Quadrille Publishing is an imprint
of Hardie Grant
www.hardiegrant.com.au

Text © 2017 Imogen Owen
Photography © 2017 Kim Lightbody
Design and layout © 2017 Quadrille Publishing

Cataloguing in Publication Data:
a catalogue for this book is available
from the British Library.

ISBN 978-1-84949-907-1

Printed in China

IMOGEN OWEN
LETTERPRESS & LETTERING
HANDMADE BY NICE PEOPLE IN ENGLAND
IMOGENOWEN.COM